D1333763

Front cover: Stone idol from Co. Donegal, period 300 BC-500 AD (Fermanagh County Museum).
Rose O'Neil, c.1680-1728; by Garret Morphey (National Gallery of Ireland).
An Irish Freeholder, 1829; cartoon (National Library of Ireland).
A Killarney girl, c.1860-80; photograph (National Library of Ireland).
Inside front cover: The National Library of Ireland.
Inside back cover: The Reading Room, National Library.

First published in 1986 by the National Library of Ireland

British Library Cataloguing in Publication Data:

 Kissane, Noel
 The Irish Face
 1. Irish in art 2. Face in art
 I. Title II. National Library of Ireland
 74.9'42 N8219.I7

 ISBN 0 907328 12 1

Printed by Mount Salus Press.

Photographs

Photographs have been supplied by institutions and individuals cited in the text and by the following: Commissioners of Public Works in Ireland: 2, 3, 19, 24; Department of Archaeology, University College Dublin: 25; Fergus O'Farrell Ltd: 52; National Museum: 1; Northern Ireland Tourist Board: 8; Pieterse-Davison International: 30, 31, 32, 51; Sotheby Park Bernet: 50; Nóra Iníon Uí Shúilliobháin: 35; Ulster Museum: 4. As there are particular difficulties in locating items in archival collections we include reference numbers for the following: British Library: 27 (Harleian 1319); National Library of Ireland: 21(R.19000); 22(R.19001); 23(R.19002); 33(R.19030); 37(R.19003); 38(R.19004); 39(R.19005); 40(R.19006); 55(R.19007); 56(R.19008); 57(R.19009); 74(R.19010); 75(R.19011); 76(R.19012); 77(R.19013); 78(R.19014); 80(R.19015); 81(S.P. 2853); 83(R.19016); 85(R.1455); 88(R.19017); 100(R.19018); 101(R.19019); 102(R.19020); 103(R.19021); 104(R.19022); 105(R.19023); State Paper Office: 96(GPB. PR 52); 97(GPB. PR 35); 98(GPB. PR 43); 99(GPB. PR 13).

Noel Kissane

The Irish Face

THE NATIONAL LIBRARY OF IRELAND
1986

Foreword

The National Library of Ireland has published many bibliographies and guides to its collections over the years. These have included bibliographies of Irish language and literature, a catalogue of Irish portraits and a catalogue of Irish topographical prints and drawings. The best-known works issued by the Library are those edited by a former Director, R.J. Hayes, the eleven volume *Manuscript Sources for the History of Irish Civilisation* (1965) and the nine volume *Periodical Sources for the History of Irish Civilisation* (1970). A three volume supplement to *Manuscript Sources,* edited by D. Ó Luanaigh, was published in 1979.

Source books such as those mentioned are of great benefit to scholars and research workers. In recent years the Library has been catering for a wider public especially amongst younger people. We have issued folders of facsimile documents on subjects such as Daniel O'Connell, the Land War and the G.A.A. The eleven titles in this series have introduced the Library and its resources to many people who have not had the opportunity of actually visiting the Library. While the National Library intends to publish further titles in the series of facsimile documents this present publication marks a new departure. The *Irish Face* is the first of a series of occasional colour booklets on topics of interest to young and old. For this subject it has been appropriate to go beyond the collections of the National Library and we are grateful to those institutions and individuals who have allowed items in their collections to be reproduced. These are individually acknowledged where we were free to do so; the owners of some paintings wish to remain anonymous.

The Library acknowledges the support of the National Touring Exhibitions Service, which operates under the aegis of the Department of The Taoiseach, in providing funds for an associated exhibition. We are grateful to Allied Irish Banks and the Ulster Bank for contributions towards defraying the costs of the exhibition. We are especially grateful to an anonymous donor who has very generously provided the major part of the funds needed to produce this booklet.

Michael Hewson
Director
National Library of Ireland

Abbreviations

NGI:	National Gallery of Ireland	RDS:	Royal Dublin Society
NLI:	National Library of Ireland	TCD:	Trinity College, Dublin
NMI:	National Museum of Ireland	UM:	Ulster Museum

Sources for quotations in the text are on page 62

Acknowledgments

The following institutions and their staffs have contributed in various ways towards the compiling and publication of this booklet and an associated exhibition, and are acknowledged with gratitude: Aer Lingus; Altnagelvin Hospital, Derry City; the Arts Council; Birr Scientific Heritage Society; Bord Fáilte and Mr Paddy Tutty (Photographer); the British Library; Castleknock College and Very Rev Kevin O'Shea, Principal; Conradh na Gaeilge and Mr Seán Mac Mathúna, Rúnaí; the Crawford Municipal Gallery, Cork, and Mr Peter Murray, Curator; the Department of Irish Folklore, University College, Dublin, especially Ms Barbara Ó Floinn; *Feasta;* Fergus O'Farrell Ltd; Fermanagh County Museum and Ms Helen Lanigan-Wood, Curator; the Green Studio; the Hugh Lane Municipal Gallery of Modern Art, Dublin, Ms Eithne Waldron, Curator, and Ms Patricia Flavin; the Irish Georgian Society; Lambeth Palace Library and Mr E.G.W. Bill, Librarian; Mount Salus Press, especially Mr Paddy Burns; the National College of Art and Design, Mr Noel Sheridan, Director, Mr Bill Bolger and Ms Fiona Hayes of the Department of Visual Communication (for design of booklet cover, poster and exhibition); the National Gallery of Ireland, Mr Homan Potterton, Director, Ms Marie Bourke, Ms Frances Gillespie, Mr Michael Olohan (Photographer), Ms Anne Stewart and Dr Michael Wynne; the National Library of Ireland Society; the National Museum, Mr A.B. Ó Ríordáin, Director, and various members of staff, especially Ms Debbie Caulfield, Mr Brendan Doyle (Photographer), Mr John Farrell, Ms Margaret Lannen, Mr Joseph Murray, Ms Nessa O'Connor, Ms Mairéad Reynolds, Mr Pádraig Ó Snodaigh, Mr John Teahan and Dr P.F. Wallace; the National Museum of Scotland; the Northern Ireland Tourist Board and Ms Betty Wilson, Librarian; the Office of Public Works — National Parks and Monuments Branch, Mr Jim Bambury (Photographer) and Mr John Scarry; the Photographic Society of Ireland, Mr Tom O'Flaherty, President, and Ms Moira Gillespie, Past-President; Print Production and Mr John McCurrie; the Public Record Office of Ireland, Dr David Craig, Acting Director, Mr Leslie Burbage (Photographer), Mr Ken Hannigan and Ms Anne Neary; Routledge and Kegan Paul; the Royal Dublin Society and Mr Alan Eager, Librarian; the Royal Irish Academy and Mrs Brigid Dolan, Librarian; St Patrick's College, Maynooth, Rt Rev Msgr Michael Ledwith, President, Mr Loughlin J. Sweeney and Ms Valerie Seymour; Triangle Promotions Ltd; the Board of Trinity College, Dublin, and Dr Bernard Meehan, Keeper of Manuscripts; the Ulster Folk and Transport Museum, Mr G.B. Thompson, Director, Mr Kenneth Anderson (Photographer), and Dr W.H. Crawford; the Ulster Museum, Mr James Nolan, Acting Director, Mr Martyn Anglesea and Dr Brian Scott; Waterford Corporation and Ms Aoife Leonard, Archivist; Woburn Abbey and Ms Lavinia Wellicome, Curator; the Zankel-West Collection, New York.

The assistance of the following individuals is gratefully acknowledged: Mr Robert Ballagh, Mr Joe Collins, Ms Cliodna Cussen, Baron Brian de Breffny, Dr Máire Delaney, Mrs Joan Duff, Prof George Eogan, Ms Marjorie FitzGibbon, Mr Leo Higgins, Mr Justin Keating, Ms Lina Kernoff, Mr Brian King, the Knight of Glin, Mr Louis le Brocquy, Rev Prof Martin MacNamara, MSC, Mr Kevin McNamee, the Rt Hon Viscount Massereene & Ferrard DL, Aoibhean Iníon Mhic Dhonncha, Mr Christopher Moore, Ms Clare Morris-Eyton, Ms Betty O'Brien, the late Tomás Ó Muircheartaigh, Prof Domhnall Ó Murchadha, Prof T.P. O'Neill, Mr Flann Ó Riain, Mr Domhnall Ó Súilleabháin, Mrs Irene O'Sullivan, Mr Michael O'Sullivan, Mr James Power, Ms Mary Power, Mr Robert Pyke, Ms Hilary Richardson, Lord Rosse, Mr Thomas Ryan PRHA, Mrs Nora O'Shea, Mrs J.M. Thomas, Nóra Iníon Uí Shúilliobháin, Ms Micheline Kerney Walsh. Special thanks to Prof Anne Crookshank and Dr Peter Harbison, both of whom read the manuscript text and made a number of helpful suggestions. Finally, several members of the staff of the National Library have contributed in various ways, most notably Ms Teresa Biggins, Mr Tom Desmond, Mr Gerard Long, Mr Feargus Mac Giolla Easpaig, Mr Brian McKenna, Mr. Martin Ryan, Dr Kevin Whelan and, especially, Mr Eugene Hogan, Photographer.

Introduction

In the eight hundred years since Giraldus Cambrensis reported that the Irish were 'uncultivated' but 'well-complexioned', foreigners have assessed us and recorded their impressions of our faces and our manners, and have sometimes speculated on our ethnic backgrounds. One of the most respected of these visitors was the Englishman Arthur Young, an authority on agriculture and rural economy, who noted in his *Tour of Ireland* (1780): 'There are three races of people in Ireland, so distinct as to strike the least attentive traveller: these are the Spanish which are found in Kerry and a part of Limerick and Cork, tall and thin, but well made, a long visage, dark eyes, and long, black, lank hair'. The other two races he singled out were the Scots in the North and people of Norman ancestry in Co. Wexford, and he concluded, 'the rest of the kingdom is made up of mongrels'.

Young would have been more accurate if he had asserted that the entire kingdom was made up of 'mongrels', that is people of mixed ethnic origin. In recorded history, settlers in Ireland have included Celts, Scandinavians, Normans, English, Scots, German Palatines, French Huguenots and a variety of others, none of whom could be considered homogeneous or a 'pure race'. For instance, the Normans intermingled to a significant degree with the native populations in France and Wales before they came to Ireland. Celtic-speaking settlers may have made the greatest contribution to the national 'gene pool' but they included a number of different ethnic groups. Like Arthur Young, many people have theories about physiognomy and ethnic types, but more than superficial characteristics must be taken into account in any attempt at classification. Young believed that his Spanish types in the South were descendants of soldiers who were stationed in the area from the reign of Queen Elizabeth to the time of Cromwell. However, it is unlikely that Spanish soldiers — or survivors of the Armada — were ever present in sufficient numbers to leave such obvious marks on the local population. It is in fact probable that Young was observing the descendants of people who settled in the area in prehistoric times.

Information on our ethnic origins, sketchy as it is, only extends back about two thousand years, but various immigrant peoples had been settling here for at least six thousand years before that. We can only speculate as to what these earlier inhabitants of the country looked like, but it is likely that the genes of some of these prehistoric peoples still persist in Ireland and perhaps shadows of their faces may be glimpsed in ourselves or our neighbours. The immediate predecessors of the Celts, the peoples of the Bronze Age (c. 2000-300 BC) have left us no statues or portraits but they must have been vain about their appearance. Of the numerous gold ornaments that survive from their time a great many were designed to set off the face, probably of men as well as women: collars, lunulae, gorgets and torcs for the neck, rings for the ears, and various practical or impractical embellishments for the hair.

Until recent centuries, the Irish were remarkably reticent about recording themselves in any visual medium, but the language and the literature have always indicated a lively

interest in facial appearance. In ordinary speech there are countless expressions such as 'he had a *liobar* of lip that would trip him', or 'you'd think his old head had worn out three or four bodies'. Epithets and nicknames still to be heard suggest a similar awareness: *gobán* (big-mouth), *cluasach* (big-ears), *scrogall* (long-neck). Physical beauty has always been highly regarded by the Irish, and this attitude is well attested in folk tradition. The fairies only carried off those who were strong and handsome and, in the days when marriage was arranged on economic principles, a pretty face could count as a bargaining factor.

One Irish ideal of beauty is outlined in poetic terms in the ninth century text which describes Edaín the Fairy:

'. . . her clear and lovely cheeks were as red as the foxglove of the moor. Her eyebrows were as black as a beetle's wing; her teeth were like a shower of pearls in her head; her eyes were as blue as the bugloss; her lips were as red as vermilion . . . a dimple of sport in both her cheeks, in which there came and went flushes of fast purple as red as the blood of a calf, and others of the bright whiteness of snow. A gentle, womanly, dignity in her voice . . .'

Nearer to our own time the great Edmund Burke philosophised on the nature of beauty and for him the emphasis had to be placed on those inner and more spiritual qualities without which even the most perfectly formed face is mere plastic:

'She is handsome, but it is a beauty not arising from features, from complexion and shape. She has all these in a high degree, but whoever looks at her never perceives them, nor makes them the topic of his praise. 'Tis the sweetness of temper, benevolence, innocence and sensibility which a face can express that forms her beauty . . .'

This booklet illustrates the faces of a selection of Irish people, anonymous or celebrated, from various periods through the ages, and it reviews the artists and the techniques and media employed in their portrayal. It also gives some indications of the 'look' in fashion at different times, and of how the Irish liked to present themselves to the world.

1. Prehistoric Stone Carving

Although Ireland has been inhabited by successive waves of immigrants for at least eight and a half thousand years, the earliest known representations of the human face date from the period 3000-2500 BC. The three most notable specimens were discovered in passage tombs in Co. Meath, two at Knowth which is near Newgrange and the Boyne, and the third at Fourknocks, near the border with Co. Dublin. The tombs are huge circular mounds with one or more stone chambers at the core, entered through a narrow passage. In the society of the time, the dead were cremated and the remains were deposited in the stone chambers. Rather similar tombs are to be found along the Atlantic seaboard from Ireland to Spain, and presumably this type of monument was introduced into Ireland by immigrants from the Continent.

A remarkable feature of some of the tombs is a form of decorative inscription on stone which, in this Stone Age period, must have been executed with punches and chisels made of flint. The elements of the decoration are geometrical, and consist of circles and spirals, diamonds and straight lines. The designs appear to be symbolic and, as they are associated with burial sites, they probably had religious significance. It is an abstract form of art where the intention is not to represent an actual picture of anything, but in a few instances the geometrical shapes are used to produce what seem to be rather stylised renderings of the human face. It is by no means certain that the carvings were intended to represent faces but, in some respects, they resemble more obvious depictions of the human face which appear in passage tombs on the Iberian Peninsula.

As they occur only in association with burial sites, it is possible that these faces represented gods. The vagueness of the portrayal may have been intended to convey their shadowy nature, part human and part supernatural, and designed to inspire awe and wonder.

1. Flint ceremonial macehead found in tomb at Knowth in 1982, in an archaeological context which dates it to the period 3000-2500 BC. It has a circular hole for the handle. The decoration is in relief, the background surfaces having been worked down with a stone tool, possibly of quartz. 79 mm (3·125 inches) in height.

2. Carving on stone in passage of tomb at Knowth, Co. Meath, c. 3000-2500 BC.

3. Stone in tomb chamber at Fourknocks, Co. Meath. The two lines forming a crescent around the lower face may have represented a neck ornament such as a lunula, made from some Stone Age material such as leather; c. 3000-2500 BC.

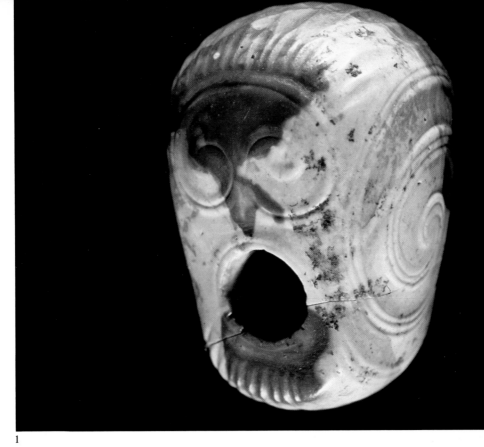

1

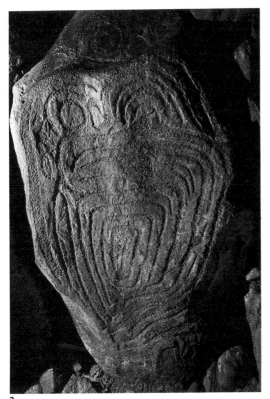

2

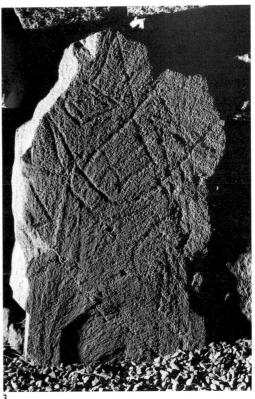

3

2. Celtic Idols

After the mysterious carvings of the passage tombs, there seem to have been no portrayals of the human face until two thousand years later when the Celts reintroduced the practice. The Celts were a group of related tribes who spoke various dialects of the Celtic tongue. They became prominent in the area of Bohemia and Bavaria in central Europe and, from the eighth century BC, they colonised vast territories including France, Spain, Britain and eventually Ireland. Their religion involved the worship of gods in the form of human heads carved from wood or stone. A number of these idol figures survive from the pagan Celtic period, that is from about the third century BC to the coming of Christianity in the fifth century AD. Apart from the idols, the human face was rarely portrayed by the Celts, possibly because they regarded the human head as sacred and not a fitting subject for secular art. Also, their art was generally non-representational and tended to consist of abstract designs constructed from flowing curved lines and spirals.

The Celts on the Continent have been described by Greek and Roman authors. Also, the great corpus of Irish literature written down about the ninth century AD reflects the culture of the pagan Celtic period and provides numerous physical descriptions; for instance, the *Táin Bó Cuailnge* tells of one warrior who is 'fiery and swarthy-faced', another who has black, cropped hair with 'a grey, bright eye in his head', and a third who is 'a long-cheeked sallow-faced man' with black hair. The impression given is that there was a variety of physical types which suggests a number of different tribes and possibly the continued existence of a pre-Celtic population. Tall, blue-eyed, blond types seem to have been highly regarded and to have predominated at least among the aristocracy, but another Celtic ideal of beauty is revealed in the story of Deirdre. When she sees a raven drinking the blood of a skinned calf from the snow, she proclaims: 'I should dearly love any man with those three colours, with hair like the raven and cheek like the blood and body like the snow'.

4. The stone 'Tanderagee Idol' from Co. Armagh. (Armagh Cathedral)

5. Wooden idol carved from yew, found c. 1910 in a bog at Ralaghan, near Shercock, Co. Cavan. (National Museum of Ireland)

6. Stone idol from Beltany Stone Circle in the Raphoe area of Co. Donegal. Faint traces of a decorated collar on the neck help in dating it to the pagan Celtic period. (Fermanagh County Museum)

7. Stone idol from Togher, near Finnea, Co. Westmeath. (NMI)

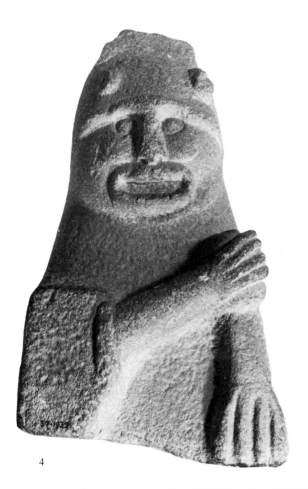

4

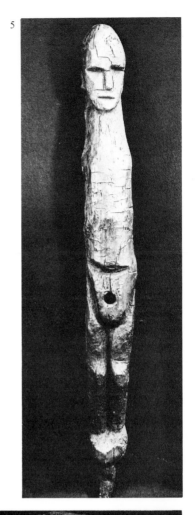

5

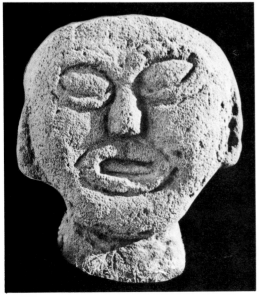

6

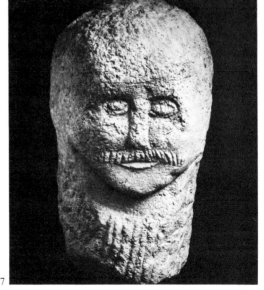

7

11

3. Two-Faced Idols

Most of the Celtic idol figures consist of a head and face but there are a few instances where the head is two-faced or three-faced. The significance of these formats is unclear but the probable intention was to represent the idea of all-seeing, and so extremely powerful, deities. While the figures, whether single or multiple-faced, were intended to represent gods rather than human beings, in appearance they may well reflect particular social classes of the time, for instance the kings or the druids. Some of the figures are bearded, some have moustaches only and others show no facial hair. A similar diversity in Celtic fashions is recorded both by Greek and Roman writers, and by Irish literature. Furthermore, the numbers of combs and razors found in archaeological sites suggest that considerable care was given to the hair.

The different shapes of head represented by the idol figures may be significant. Archaeological examination of skulls from Celtic sites suggest there were round-headed types and long-headed types. Irish literature occasionally notes this distinction and seems to attach some importance to it, possibly because it reflected some ethnic or social divisions within the population. The heads of the Boa Island figure could possibly belong to either type, but its faces have a distinctive tapering shape, such as the *Táin* ascribes to a particularly handsome hero: 'Not many heroes are more beautiful than the hero in the forefront of that band. Cropped, red-yellow hair he had. His face was narrow below and broad above'. It is the same shape of face which is celebrated in one of the most evocative passages in Celtic literature, the description of Froech in the Dark Pool: 'the body so white and the hair so lovely, the face so shapely, the eye so blue, and he a tender youth without fault or blemish, with face narrow below and broad above, and he straight and spotless, and the branch with the red berries between the throat and the white face'.

8. Two-faced stone idol on Boa Island in Lower Lough Erne, Co. Fermanagh. It consists of two busts set back to back, each with crossed limbs, pointed beard, curling moustache and hair shown at the junction of the figures.

9. Stone bust found c. 1855 at Corraghy, Co. Cavan. It was then part of a two-faced figure, the other side of which was a ram's head; the ram possibly symbolised fertility. The ram's head was destroyed in an attempt to separate the two. (NMI)

10. Three-faced stone idol from Corleck, Co. Cavan, found c. 1855 possibly at the same place as the Corraghy bust. The three faces are similar, but not identical. (NMI)

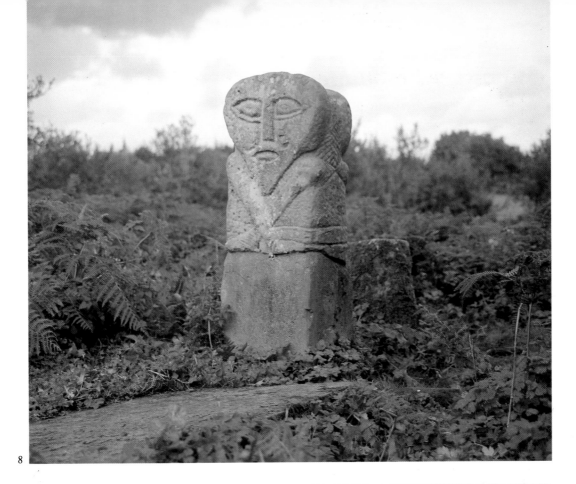

8

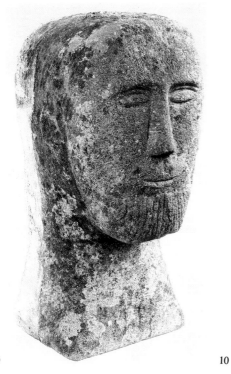

9

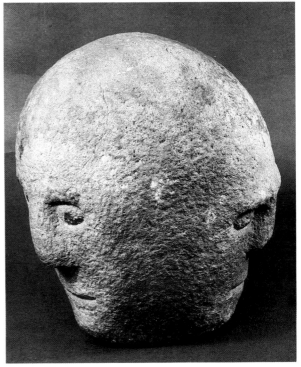

10

13

4. Christian Period Metalwork

In the period after the mission of St Patrick in the fifth century, Ireland gradually evolved from a pagan to a Christian society, and craftsmen in stone and metal found a new orientation for their art. The carving of idols was discontinued, and the workers in metal proceeded to cater for the requirements of the new religion, and turned out articles such as altar vessels, croziers and caskets for the relics of the saints. The art which they applied to the decoration of these artefacts was in the old Celtic style with its sinuous curves and spirals, but it was now enriched with a number of foreign elements. It continued to be an abstract and non-representational art, and when the human face occurs in metalwork it is in the tradition of the Celtic idols, with large lens-like eyes and is more in the nature of a mask than a face. Often it is just one element in a complex decorative design, as for instance on the Derrynaflan Chalice where two heads are so harmoniously incorporated into a pattern of gold filigree (wire) that they almost escape notice. Again, on the Tara Brooch, which was probably intended for secular use, a pair of glass heads are so small that they are relatively insignificant in the overall decorative context.

As well as these rather incidental occurrences of the human face as decorative features, there are formal portraits of saints and biblical personalities which often form part of metal plaques embellishing shrines and caskets. These figures must have been modelled on examples brought from Britain and the Continent, but most of them are unmistakably Irish. The heads tend to be large in proportion to the bodies, and the faces lack personality and have that vacant mask-like quality already mentioned. The earlier examples often have Celtic decoration of a high standard, but from about the tenth century it is generally more crude and not so distinctively native. While most of the portraits are of biblical figures they are usually in Irish costume and, perhaps, to some extent, illustrate the general appearance of ecclesiastics and other people of the time.

11. Head on an Irish hanging-bowl (probably a holder for a lamp) found in a Viking tomb at Miklebostad, Norway; period late 6th-early 7th century. (Bergen Museum)

12. The head of Christ; detail from a gilt bronze crucifixion plaque from St John's (Rinnagan) near Athlone. The plaque possibly decorated a book cover. Late 7th century. (NMI)

13. Ecclesiastics from a house-shaped shrine known as the *Breac Moedóic* ('Moedóc's Speckled One or Thing'), commemorating a sixth-century saint associated with Co. Wexford. The shrine is probably 9th century but the figures are 11th-12th century. (NMI)

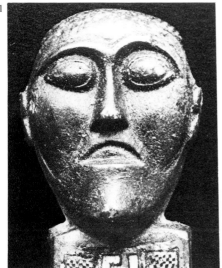

11

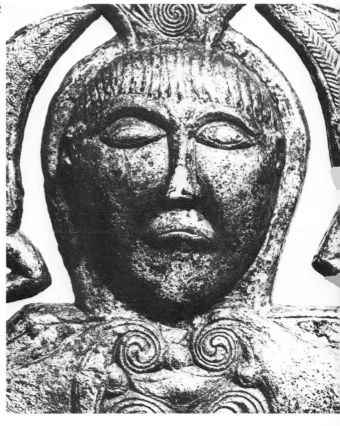

12

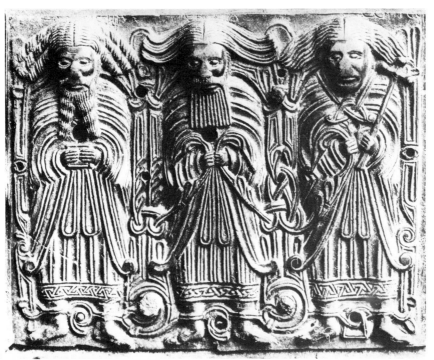

13

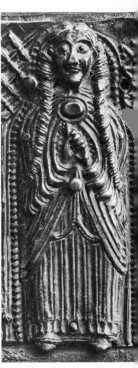

5. Illuminated Manuscripts

The illuminated manuscripts of the early Irish church are mostly copies of the Gospels, and the principal figures portrayed are Christ, the Virgin and Child, and the Evangelists. As was the case with the metal craftsmen, the manuscript artists must have used models imported from abroad. Essentially the portraits probably represent their models faithfully, and include symbols and accessories such as haloes, angels, books and staffs which were common in contemporary religious art in Europe and the Middle East. However, while it is probable that at least some of the models were naturalistic and life-like, the Irish tended to dehumanise their portraits, and the faces show few signs of life or emotion. In the configuration of the heads and faces the formal portraits seem to be rather in the tradition of the pagan stone idols. The faces, especially those in the Book of Kells, are reminiscent of the Boa Island figure, and tend to be broad at the top, narrowing into a tapering beard. The treatment of the eyes is also rather similar.

As the illuminated manuscripts are the earliest surviving Irish paintings, the colouring is of some interest. Apart from a few instances of green or blue, the hair is usually yellow or golden, reflecting perhaps the ideal of the fair-skinned blond so often expressed in Celtic literature. There is no evidence that hair was dyed in that period, but it is likely that the colour was sometimes lightened by bleaching. The agent used was probably stale urine, the ammonia content of which was more than adequate for the purpose. In the manuscripts the hair shows signs of careful grooming. The style is generally shoulder-length, with locks or a fringe grown low on the forehead in a suggestion of the Irish 'glib' — in the later Middle Ages the authorities disapproved of the glib as it made men difficult to identify. Beards are generally represented as yellow, red or occasionally black but some figures appear shaven. This may reflect contemporary practice as clerics in the early Irish church were usually clean shaven.

14. Christ in the Book of Kells. Four illustrators have been distinguished in the Book; this is by 'the Portrait Painter' who has constructed a surround of peacocks and angels. Early 9th century. (Trinity College Library, Dublin)

15. The Evangelist St Matthew in the Book of Durrow. He is thought to have the early Irish form of tonsure which involved shaving the front rather than the crown of the head. This practice was banned at the Synod of Whitby in 664 AD. Second half 7th century. (TCD)

16. The Evangelist St Luke in the Gospels of MacDurnan. Late 9th century. (Lambeth Palace Library, London)

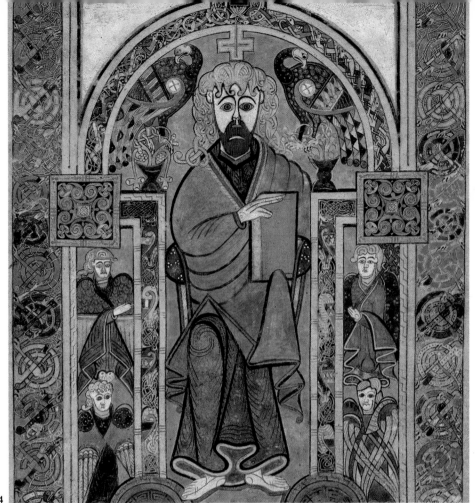

14

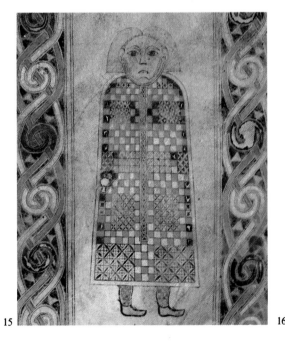

15

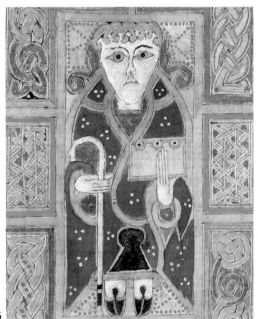

16

17

6. The Vikings

The Vikings in Ireland have traditionally been differentiated as 'white foreigners' from Norway (*Finn Gall*) and 'black foreigners' from Denmark (*Dubh Gall*). However, dark types would have been a minority among the Danes and it has been suggested that *Finn* and *Dubh* indicated time of arrival rather than colour and respectively denoted the first Vikings in Ireland, the Norse, who appeared in 795 AD and the later arrivals, the Danes, who came fifty years afterwards. In any case the Norse were by far the more numerous in Ireland and the predominant type must have been blond, fair-skinned and blue-eyed. Some indications of their appearance are provided by contemporary figurines, incised representations on stone and wood, and possibly by relief carvings on Irish high crosses. A characteristic portrayal shows them in trews (breeches) and with their hair tied back on the poll; invariably they sport prominent moustaches and fine beards, worn long, plaited, forked or trimmed. The archaeological evidence from Wood Quay in Dublin suggests that hair was well cared for. Unlike the Celts, the Vikings do not seem to have shaved, so no razors have been identified, but among the remains were hair-combs, hair-nets and tweezers. The skeletal remains suggest that teeth were not as well cared for as hair and, as they were not regularly cleaned, the gums often show signs of infection. The coarse nature of the Viking diet contributed to healthy teeth, but it also caused excessive wear. The wear and the infections seem to have resulted often in recession of the gums and many people must have been toothless.

Though dating from the thirteenth century, the Norse sagas provide information on physical types which must have been common in Viking Ireland. Rather direct indications of appearance are given by the nicknames which proliferate: the White, the Red, the Grey, the Black; Jutting-Beard, Silk-Beard (Sitric, King of Dublin) and Old-Beardless; Flat-Nose, Hook-Eye and Sleekstone-Eye. Like most other peoples, the Vikings were not uniform in appearance, and even in individuals incongruities could appear, as was the case with one Skarp Hedin: 'He had curly chestnut hair and handsome eyes. His face was very pale and his features sharp. He had a crooked nose and prominent teeth which made him ugly round the mouth'.

17. Skull of a young well-built male, probably a Viking, excavated from a 10th century earthenwork fortification at Fishamble Street. There are three cuts on the right side of the head, any of which could have caused death. (NMI)

18. Profile in bone of male or female figure featuring contemporary 'bun' hairstyle. From Hiberno-Norse period, Christchurch Place, Dublin. (NMI)

19. Carved panel on Muiredach's Cross at Monasterboice, Co. Louth. Shows the arrest of Christ by soldiers, thought to be represented by Vikings with typical swords, trews and moustaches. Probably mid-9th century.

20. A head, possibly a portrait, incised on a stone slab, Jarlshof, Shetland Islands. (National Museum of Antiquities of Scotland, Edinburgh)

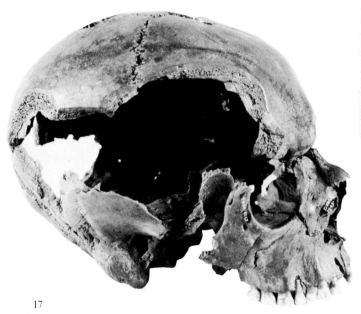

17

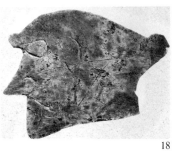

18

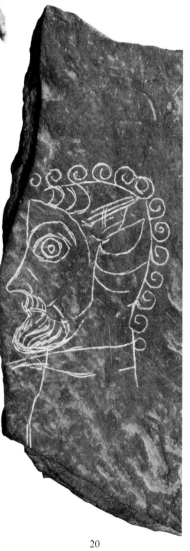

20

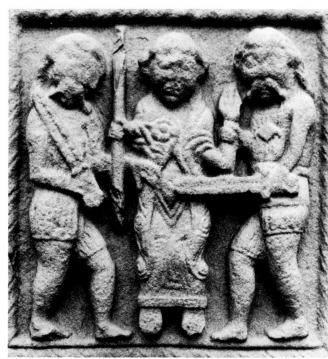

19

19

7. Cambrensis and the Normans

Giraldus de Barri, known as *Cambrensis* (the Welshman), was a priest who made two lengthy visits to Ireland in the decades following the Norman invasion. The trips provided material for two books in Latin, the *Topography of Ireland* and the *Conquest of Ireland,* both written by 1189. The *Topography* shows Giraldus as a rather prejudiced observer and his judgment on the Irish was, 'according to modern ideas they are uncultivated, not only in the external appearance of their dress but also in their flowing hair and beards. All their habits are the habits of barbarians'. Of children he says: 'the midwives do not use hot water to raise the nose, or press down the face, or lengthen the legs'. However, he believes that nature more than compensates for this neglect and that 'it forms and finishes them in their full strength with beautiful upright bodies and handsome and well-complexioned faces'.

The *Conquest* is a more reliable source in that Giraldus was a member of an aristocratic Norman-Welsh family and related by blood or by marriage to most of the leading Normans in Ireland. With his first-hand knowledge, his physical descriptions must be reasonably accurate. The impression he gives is that the Normans varied greatly in appearance. In stature they ranged from the tall, through the medium, down to Meiler FitzHenry who was 'not much more than tiny but possessed great strength considering his size'. Colouring is equally diverse, and there are descriptions of some who were dark and swarthy, of others who were red haired, and of John de Courcey whose hair was 'a lighter shade than fair, tending in fact towards white'.

The texts are preserved in a number of manuscripts some of which have colour illustrations. Those relating to the *Topography* are generalised pictures of various common types of Irish people, but a manuscript in the National Library of Ireland has an additional series of portraits. These include nine Normans and also Diarmait MacMurchada. They may have been executed under the direction of Giraldus. While they do not agree in matters of detail with his written descriptions, they are probably reasonably accurate pictures, but they cannot be considered as portraits in the modern sense.

21. Diarmait MacMurchada. Giraldus never met Diarmait and his description is sketchy: 'Diarmait was tall and well built, a brave and warlike man among his people, whose voice was hoarse as a result of constantly having been in the din of battle'. (National Library of Ireland)

22. Maurice FitzGerald, uncle of Giraldus and ancestor of the two great dynasties, the Kildares and the Desmonds. Giraldus describes him: 'Maurice was a modest and dignified man with a high complexion and distinguished features, in stature moderately short'. (NLI)

23. Hugh de Lacy. Described by Giraldus: 'He was dark, with dark, sunken eyes and flattened nostrils. His face was grossly disfigured down the right side as far as his chin by a burn, the result of an accident. His neck was short, his body hairy and sinewy'. (NLI)

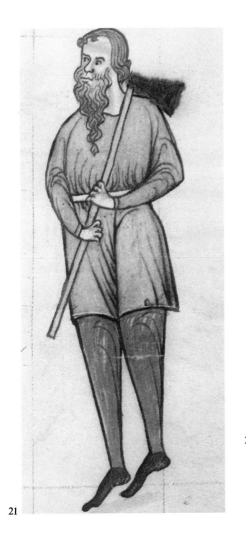

21

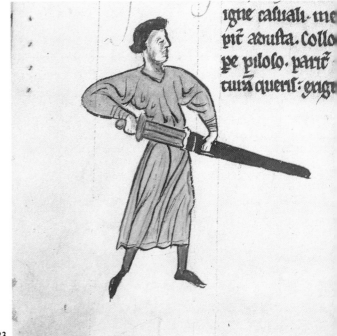

22

23

8. Medieval Stone Carving

Until recent centuries sculpture in Ireland was normally produced in a religious rather than a secular context. For the Christian period up to the coming of the Normans, the most extensive corpus of figure sculpture is that provided by the high crosses. In these the figures are carved in relief, that is the background is cut away leaving the figures standing out. The subjects are mostly scriptural with personalities from the Old and New Testaments. The figures are usually less than a foot high, and even where the faces were given a naturalistic treatment the weathering of a thousand years has eroded the finer detail.

From the same period, the ninth to the eleventh century, there are a number of figures which were designed as corbels or caryatids, that is supports for a shelf or other structure. They include a remarkable series of six from White Island in Lower Lough Erne in Co. Fermanagh, and a well-executed example in Lismore Cathedral. They are in contemporary Irish costume, but most of them represent characters from Scripture, and their purpose is to convey aspects of the Christian message.

In the twelfth century, the Romanesque style of church architecture was introduced from Britain and the Continent. This style, characterised by its Roman arches, often featured elaborate decoration on the surrounds of doors and windows. Sometimes the decoration incorporated human heads, possibly echoing the cult of the severed head in parts of France in the pagan period. In any case the portrayal of the human head was not alien to Irish art, and Irish masons and sculptors soon adopted this aspect of the Romanesque. The heads do not seem to have represented any particular persons or to have had any obvious symbolic significance. A seemingly related phenomenon is the type of female figure known as Sheila-na-Gig (probably from *Síle na gCíoch* — Sheila of the Breasts). These grotesque figures displaying their genitalia are mostly associated with late medieval buildings. Like the Romanesque heads they may have had pagan associations but their role appears to have been based on religion or superstition in that they were intended to ward off evil.

24. Decoration over doorway of Clonfert Cathedral, Co. Galway. The head in the centre might well be a portrait but the others are impersonal and resemble masks. Late 12th century.

25. Caryatid, possibly ninth century, from the monastery at Lismore, Co. Waterford, now built into the wall of St Carthage's Cathedral. The seated figure holds a book with a Latin inscription referring to 'the table of the Lord'; the context of the inscription is unclear and the figure has not been identified but is probably biblical rather than local.

26. 'Sheila-na-Gig' from an old church in Cavan which no longer exists. The figure is in a standing posture and the v-shaped incisions on the chest may represent ribs. Probably late medieval period. (NMI)

22

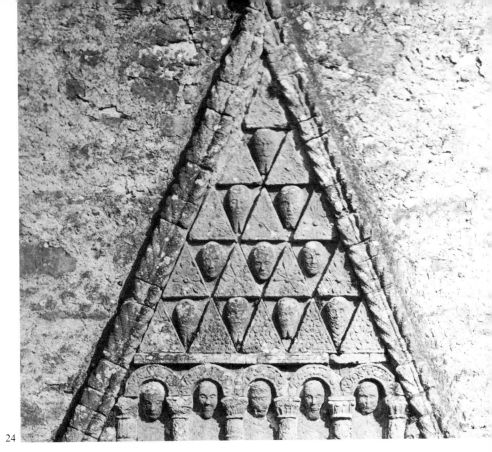

24

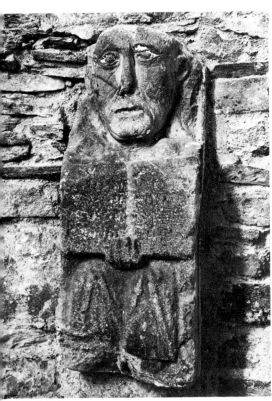

25

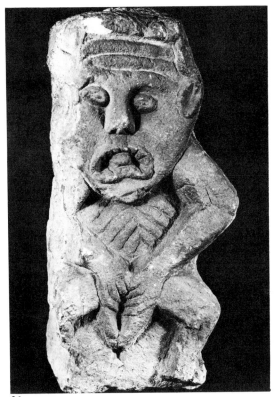

26

23

9. Medieval Illustrations

There are few illustrations of Irish people in the Middle Ages and, apart from some sketches, none by native artists. Most other European countries are pictorially well documented, and our situation may be due to the fact that Irish art had always been abstract and there was no tradition of recording either people or events by means of pictures. The few illustrations which do exist are mostly generalised representations of types and show little individual detail. For instance, the contemporary picture of Art MacMurrough Kavanagh riding down a mountain to meet Richard II was drawn by a French artist who had to work from a description. The author of the manuscript in which the illustration appears, Jean Créton, actually witnessed the meeting, but his description of Art is skimpy: 'He was a fine large man and wondrously active. To look at him he seemed very stern and savage and an able man'.

Detailed written descriptions are also rare, but there are informative passages in various laws requiring that the Norman-Irish conform to a contemporary English fashion of short hair, neatly trimmed beard and shaven upper lip. A statute of 1297 castigates those Normans who, 'having their heads half shaven grow the hair from the back of the head which they call the culan . . . whereby it frequently happens that Englishmen reputed as Irishmen are slain'. By 1537 the authorities were concerned with the population at large, and a statute of that year ordains: 'No person ne persons, the King's subjects within this land being, shall be shorn or shaven above the eares or use the wearing of haire upon their heads like unto long lockes, called glibbes, or have any hair growing on their upper lippes, called or named a crommeal'.

In the course of the Tudor conquest in the sixteenth century, a number of foreign observers recorded their impressions of the Irish in illustration and in literature. Most notable perhaps was Edmund Spenser, who deprecated the fashion of the glib as he believed that, in order to escape detection after committing a crime, the Irishman either cut off his glib or pulled it so low over his eyes that 'it is very hard to discern his theevish countenance'.

27. The attendants of Irish soldiers whom the German artist Albrecht Dürer sketched on the Continent in 1521. They show the Irish glib and moustache of the period. (NGI)

28. Richard Mór Burke (died 1243). From a late sixteenth century manuscript in Irish on the history and genealogy of the de Burgo family. It illustrates a sixteenth century style of hair, beard and moustache. (TCD)

29. The meeting of Art MacMurrough Kavanagh and Richard II in 1399. (British Library)

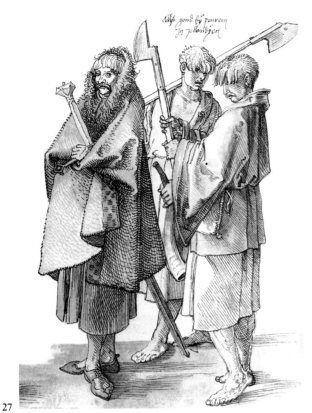

27

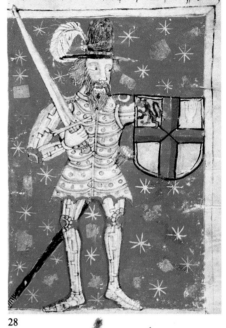

28

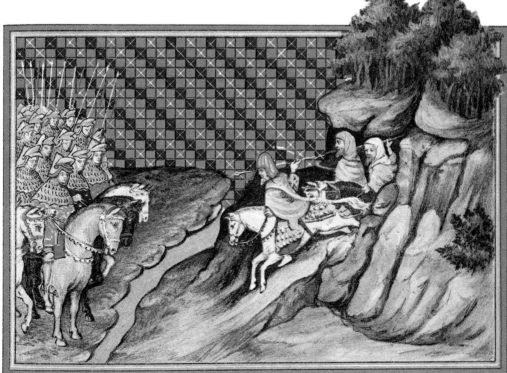

29

10. Tomb Effigies

For the medieval period drawings of Irish people are rare, but there is a great corpus of stone sculpture which provides information on the appearance of ecclesiastics and the aristocracy. Some of the figures are in a damaged state, but nevertheless they are an important source for the study of such matters as costume, armour and hairstyles. Most of the figures are associated with tombs and take the form of effigies of the deceased. Though the effigies represent individuals, they are not portraits in the modern sense. Generally in European art up to the fifteenth century, the artist did not aim at presenting a detailed likeness but rather tried to convey the status, profession and character of the person. There was little interest in facial features, and the same face could serve for saint, monk or king, the three being distinguished perhaps by costume and the symbols of halo, tonsure or crown. Also, in the case of the tomb effigies, the subjects were usually dead for some time and, in most cases, the sculptor would have had no worthwhile form of record to guide him.

The fashion of tombs and effigies was introduced from England by the Normans, and became relatively common in the area of the Pale. There are also instances from west of the Shannon mostly commemorating bishops and abbots. In the early period the effigy-slab, carved in relief, would have been placed flush with the floor of the church, but in the fifteenth century a form of stone tomb-chest became popular. The effigy was placed on top of the tomb-chest, the sides of which were carved with figures of Christ, saints or apostles standing in niches and generally known as weepers.

There must have been many sculptors who occasionally carved tomb effigies, but a number of specialised workshops have been identified. Specimens from one patronised by the Plunkett family of Co. Meath are to be found in churches around North Leinster. In Kilkenny there were two competing workshops, that of the O'Tunney family, the first to identify its authorship by name, and the 'Ormond School', which provided memorials for the Butlers, Earls of Ormond, in Kilkenny and Gowran.

30. Effigy of a bishop at Corcomroe Abbey, Co. Clare, 13th century. The carving is in low relief and seems unfinished towards the bottom. The low mitre appears to be of an Irish type confined to the West and to districts not under English control.

31. Effigies of Piers Butler, 8th Earl of Ormond, and his wife Margaret FitzGerald, on a tomb-chest in St Canice's Cathedral, Kilkenny. Piers is wearing armour of a type common in Ireland and Margaret has a horned head-dress. Ormond School, c.1539.

32. Weepers on a side panel of the tomb-chest of an unknown woman, St Canice's. The figures are a bishop, two female saints, St Catherine with sword and wheel, Mary Magdalen (?) with ointment, crowned female saint with book. Ormond School, first half 16th century.

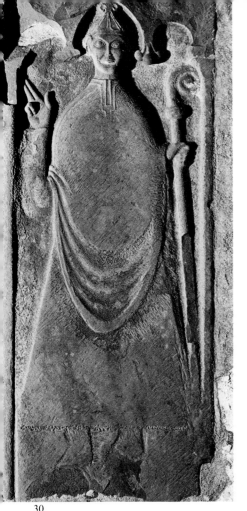

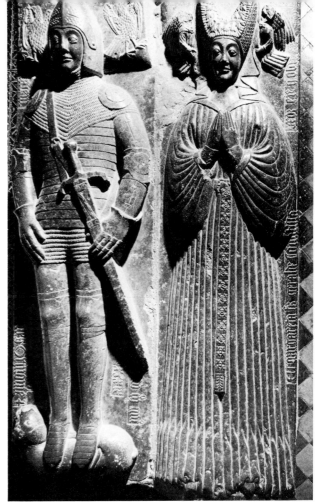

30

31

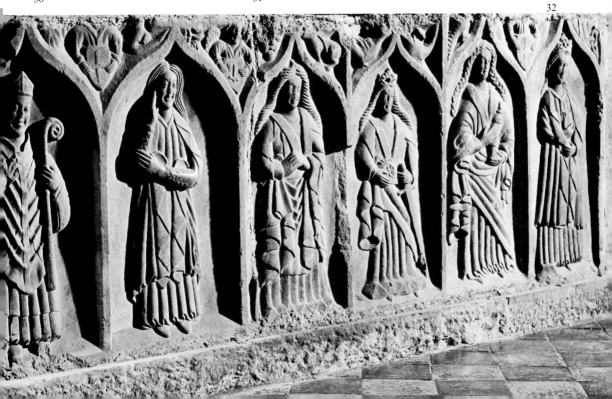

32

11. Early Painted Portraits

From the fifteenth century the humanist spirit of the Renaissance gave an impetus to the naturalistic portrayal of the human face and figure. In the more liberal atmosphere of the time there was a new respect for the individual person, complemented by a sense of curiosity about his views and opinions, and an interest in inner personality and outward appearance. Artists were now more concerned with portraying each subject as a distinctive and unique human being than as a generalised representative of a particular type or class. Painting in oils, usually on a wooden panel, became the most common form of portraiture. Artists generally tried to present the physical features of the sitter accurately and in proportion. The better artists succeeded in producing a three-dimensional effect and the illusion of a body with flesh and blood occupying a space, and the great artists were concerned with character and manner, and expressed the essential personality and nature of their subjects.

The fashion of having one's portrait painted came relatively late to Ireland, and up to the late seventeenth century almost all the artists were foreign. The earliest surviving portraits probably painted in Ireland are those of Donough and Slaney O'Brien of Co. Clare, painted in 1577 by a Flemish artist. There are a number of generalised descriptions of the Irish from this period, mostly complimentary, and one from 1620 by an English official, Luke Gernon, is worth quoting:

'The weomen of Ireland are very comely creatures, tall slender and upright. Of complexion very fayre & cleare-skinned (but frecled), with tresses of bright yellow haire, which they chayne up in curious knotts and devises. They are not strait laced nor plated in theyr youth, but suffred to grow at liberty so that you shall hardely see one crooked or deformed, but yet as the proverb is, soone ripe soone rotten. Theyr propensity to generation causeth that they cannot endure. They are wemen at thirteene, and olde wives at thirty. I never saw fayrer wenches nor fowler calliots, so we call the old women'.

33. Slaney O'Brien, wife of Donough of Lemeneagh and Dromoland. Painted on panel by a Flemish artist, 1577. (Private collection)

34. Gerald Fitzgerald, 9th Earl of Kildare, known as Garret Óg (1487-1534). School of Hans Holbein, court painter to Henry VIII. (Private collection)

35. Detail from portrait of Donall O'Sullivan Beare (1560-1618). Described by his nephew Philip: 'In stature he was tall and elegant with a beautiful face and he grew old with dignity'. He spent his last years in Spain where he was painted by a follower of the court painter Pantoja de la Cruz. (St Patrick's College, Maynooth)

36. Mary O'Brien (Máire Ruadh). On the death of her second husband, Conor O'Brien, she saved her estates by marrying a Cromwellian officer. Artist unknown but probably painted in Ireland, c. 1640. (Private collection)

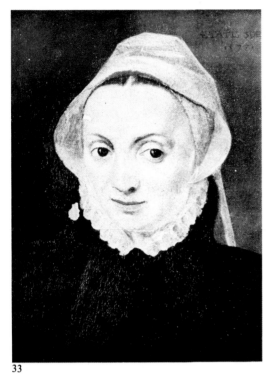

33

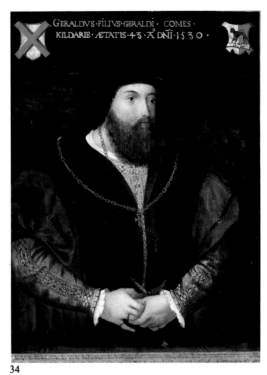

GERALDVS · FILIVS · GERALDI · COMES ·
KILDARIE · ÆTATIS · 43 · AÒ DÑI · 1530

34

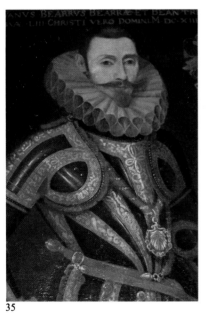

35

36

29

12. Engraved Portraits

We may prefer to look at paintings, but it is mainly from mass-produced engravings that we derive our perceptions of the appearance of personalities of the past. As printed books became more common in the course of the sixteenth century, artists were commissioned to provide illustrations suitable for reproduction. The technique involved was different from that used in traditional illustration, and the artists had to develop new skills. For instance, in the printing process the blocks from which the illustrations were impressed or printed onto the page had to be designed in reverse. At first, the blocks were of wood and the artist drew the illustration on the block in reverse. He then cut away the surrounding wood, leaving the lines in relief. These were inked and, when imprinted on the page, they left the illustration right way round. At a later date, plates of copper or other metal were used, and the lines of the illustration were sunk into the metal with a tool, or etched in with acid, again in reverse. In this process, it was the crevices which were inked and left the impression on the paper. Originally, the artist sometimes drew and engraved the illustration, but later the engraver generally used the work of other artists, with or without permission, and the professions of artist and engraver became separate and distinct.

There are not many engravings of Irish people of the sixteenth or the seventeenth centuries, and those that survive are mainly of the Irish abroad, for instance priests who were forced to emigrate for religious reasons, or soldiers or chieftains who found political asylum in France, Spain or Italy. These are usually presented in the costume and hairstyle of their adopted country, and their nationality is not always apparent.

Towards the middle of the eighteenth century an important studio of engravers was established in Dublin by a native of the city, John Brooks, and a Londoner named Andrew Miller. This studio turned out many fine portraits and, moreover, it trained a generation of engravers especially noted for a form of engraving known as mezzotint, which gives good half-tone reproduction, with a velvety type of finish. The most notable of those trained by Brooks was James McArdell who, in London, became the leading engraver of his day.

37. Hugh O'Neill, Earl of Tyrone (1550-1616). Engraving probably based on a contemporary portrait; from Primo Damaschino (Hannibal Adami), *La Spada d'Orione Stellata . . .* (Rome 1680). (NLI)

38. Thomas Carve *i.e.* Carew (1590-1672). Born Mobarnan, Co. Tipperary, priest, author and Notary Apostolic in Vienna; plate to his *Lyra, seu Anacephalaeosis Hibernica* (Vienna 1651). (NLI)

39. Rev George Walker (1618-90), Governor of Londonderry, killed at the Boyne; by contemporary London engraver John Savage. (NLI)

40. The actress Peg Woffington; a mezzotint engraving by James McArdell (c. 1728-65). From a painting by the English artist Arthur Pond. (NLI)

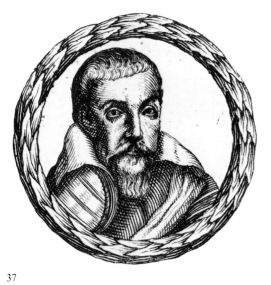

37

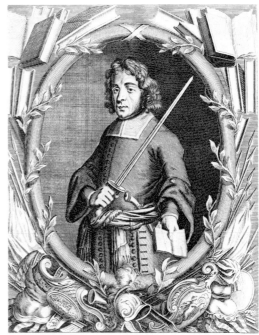

Mr GEORGE WALKER

Minister of Dunganon.

And Governour of LONDON DERRIE...

Printed for John Bowes... *Cornhill* London

39

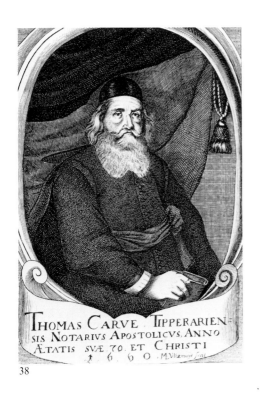

THOMAS CARVE TIPPERARIEN=
SIS NOTARIVS APOSTOLICVS, ANNO
ÆTATIS SVÆ 70. ET CHRISTI
1 6 6 0. *M.Vllzmmer fec*

38

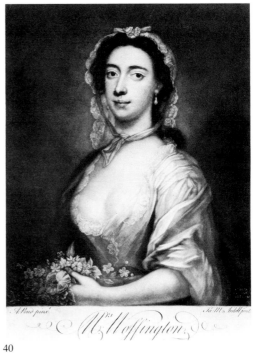

A Pond pinx. *Ja: Mc Ardell fecit*

Mrs Woffington

40

13. Irish Portraitists

There are occasional likenesses of early seventeenth century personalities painted by amateurs, but professional portrait painting by Irishmen may be said to have begun with Garret Morphey who was in business in Dublin in the latter decades of that century. In the years since then Ireland has produced many fine artists, but a high proportion of those of the first rank have chosen, or have been forced by circumstances, to work abroad. Patrons naturally prefer established reputations, and young artists have emigrated to gain experience. But each case is different: for instance Hugh Douglas Hamilton, a graduate of the Dublin Society Schools, had a good practice in Dublin painting portraits in crayons but emigrated to London when he was twenty-five. There he was popular with high society and charged nine guineas per sitter, but after fourteen years he moved to Rome and turned to painting in oils. Finally, twelve years later he returned to Dublin where he became the leading portrait artist of the time. He has left a fine legacy of Irish portraits, both in the pastels of his youth and the oils of his maturity.

A contemporary of Hamilton was James Barry, who was born in Cork. He attended the Dublin Society Schools and after five years in Rome settled in London. He might have become a greater portrait artist than Hamilton, but he considered portraiture an inferior form of art, and he devoted his talents to historical subjects, especially classical mythology. He achieved a position of some eminence in London and was for some years Professor of Painting at the Royal Academy. In terms of honours, though not of art, Barry was surpassed by another exile in London, Martin Archer Shee. This artist who was reared near Bray became President of the Royal Academy, and was knighted for his services to art. He executed numerous portraits, and we are indebted to him for a pictorial record of many of the Irish people who were prominent in London society in the first half of the nineteenth century.

41. Rose O'Neil (c. 1680-1728), daughter of Sir Neil O'Neil who was killed at the Boyne, married Col Nicholas Wogan of Rathcoffey; by Garret Morphey (*floruit* 1680-1716). (NGI)

42. Denis Daly of Dunsandle, MP (1747-91); pastel by Hugh Douglas Hamilton (1739-1808). (NGI)

43. *Ulysses and his companions escaping from Polyphemus* by James Barry (1741-1806). Ulysses (pointing) and a companion are represented by the writer and advocate Edmund Burke (1729-97) and his friend the artist. (Crawford Municipal Art Gallery, Cork)

44. Henry Grattan (1746-1820) statesman; by Sir Martin Archer Shee (1769-1850). (NGI)

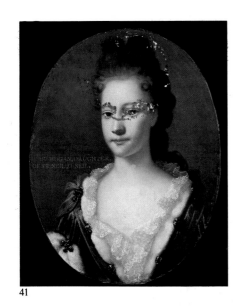

41

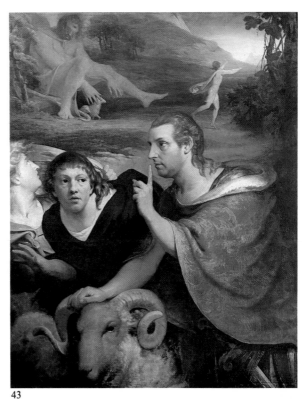

43

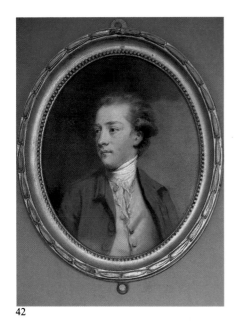

42

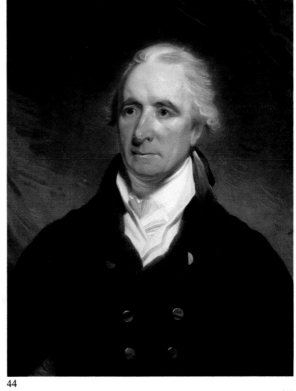

44

14. Drawings and 'The Schools'

In portraiture, a drawing often gives a more intimate view of a subject than the more formal posed painting in oils. This country is fortunate in having a very good tradition in the medium of drawing which extends back to the eighteenth century. As in various other areas of the arts, the initiative began with the Dublin Society, now the Royal Dublin Society, which around 1746 undertook the maintenance of a school of drawing. The Society was primarily concerned with promoting the economy, and hoped that the school would produce draughtsmen and designers who would make a contribution in the crafts and in manufacturing industry. The school had originally been established as a private venture by a gifted teacher named Robert West, who had trained as an artist in Paris. The Society financed the pupils who usually entered at fourteen and stayed for two years. The school specialised in drawing in chalk and crayons. Figure drawing was taught by West, who used live models as well as paintings and sculpture. The assistant teacher James Mannin, a Frenchman, taught ornament and landscape, and schools of architecture and modelling were later established. As the function of the Dublin Society Schools was primarily to produce draughtsmen rather than artists, painting was excluded and, as one contemporary commentator put it, 'to expect painters from mere workers in chalk would be to expect philosophers from a grammar school'.

Most of the graduates of the Dublin Society Schools went on to apprenticeships and careers in various areas of design and craftsmanship. Some specialised in the more artistic fields of engraving and book illustration. A number persevered in fine art, and graduates of the Schools were particularly successful in the medium of pastel. Most of the professional painters from the mid-eighteenth century onwards received their initial training in the Schools or the institutions which developed from them. The Schools were eventually located in Kildare Street, where they were taken over by the Board of Trade. In 1877 the State assumed complete ownership and the institution became the Dublin Metropolitan School of Art. Later this became the National College of Art, which in 1971 was reconstituted as the National College of Art and Design, now located in Thomas Street.

45. Dr Charles Lucas, MP (1713-71); by Thomas Hickey (1741-1824) who studied at the Dublin Society Schools; charcoal with white highlights. (NGI)

46. Thomas Moore (1779-1852), poet; by Edward Hayes (1797-1864) who studied at the Dublin Society Schools; pencil. (NGI)

47. John McCormack (1884-1945), operatic and concert tenor; by Seán O'Sullivan (1906-64) who studied at the Metropolitan School of Art; pencil. (NGI)

48. Brendan Behan (1923-64), writer; by Harry Kernoff (1900-74), born London and studied in Dublin at the Metropolitan School of Art; charcoal. (NGI)

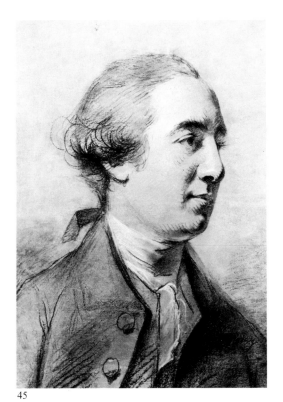

45

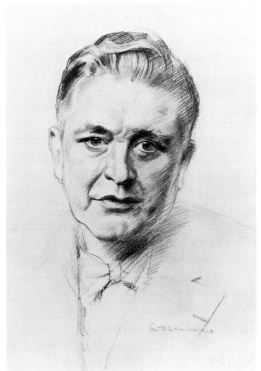

47

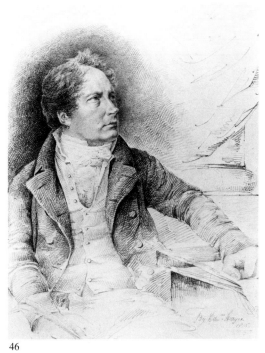

46

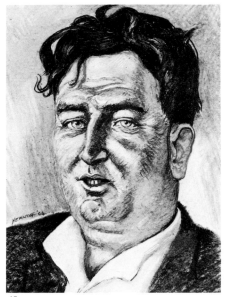

48

15. The 'Georgian' Look

Contemporary paintings and engravings, and descriptions in novels, provide much of our information about the appearance of people who lived in the eighteenth century. With regard to physical appearance, the feature which was most characteristic was the wig, a phenomenon introduced from England in the late seventeenth century. Primarily designed to conceal baldness, it was welcomed by men who wished to counterfeit the elaborate hairstyles then in vogue. Hair was worn very long but was rarely washed and, though powder was used to absorb the grease, it was difficult to maintain a presentable head of natural hair. A set of wigs, in colours to suit various occasions, enabled every man to cut a figure, and the wig was popular among the aristocracy and the gentry, the professionals and the upper middle classes until well into the nineteenth century. Upper class women wore their natural hair, sometimes dyed, and often augmented by a hair-piece. Some wore face patches of taffeta or silk, simply out of vanity or to conceal blemishes. Either sex could use face powder, and the women applied various cosmetics, many of which were concocted at home. Collections of family papers from gentry houses often include manuscript recipe books which give the ingredients of creams and colouring agents for the cheeks, the lips and around the eyes.

Among the lower orders, mens' hair gradually became shorter and some adopted the cropped look of the revolutionaries in France, in reaction to the ostentatious wigs and hairstyles of the aristocracy. For conditioning the hair, a little stale urine was added to the water when washing, and girls sometimes availed of this traditional bleach to lighten the colour of their hair. Skin disorders were common and country people had their traditional remedies. For example, butter or buttermilk were among the 'cures' for eczema or erysipelas. Other treatments were of even more doubtful efficacy, for instance the juice of an onion or the oil or slime from an eel were reputed to cure falling hair. Dental hygiene was neglected and all classes suffered from bad teeth, but for special occasions various detergents were used, the most common being soot or salt.

49. 'Speaker' Foster with his family outside Oriel Temple, Drogheda, Co. Louth, 1786. Watercolour by John James Barralet (c. 1747-1815), an Irish artist who emigrated to America. John Foster and his wife Margaretta Amelia Burgh were married in 1764; their children are Anna Dorothea, Thomas Henry, and John (on horse). Foster was the last Speaker of the Irish House of Commons and was later created Baron Oriel. (Viscount Massereene and Ferrard)

50. Detail from *The Itinerant Preacher* by Nathaniel Grogan (c. 1740-1807), a Cork artist who was the best of his generation at representing the common people. (The Zankel-West Collection, New York)

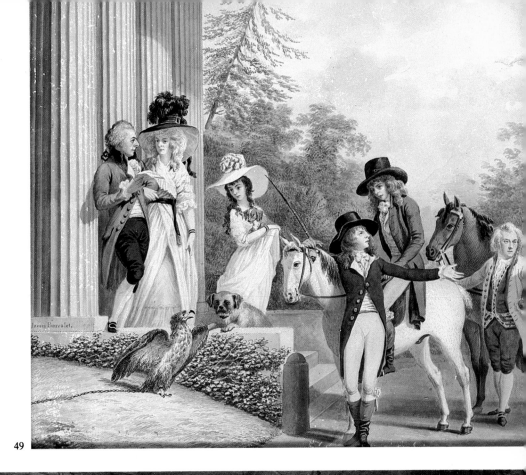

49

50

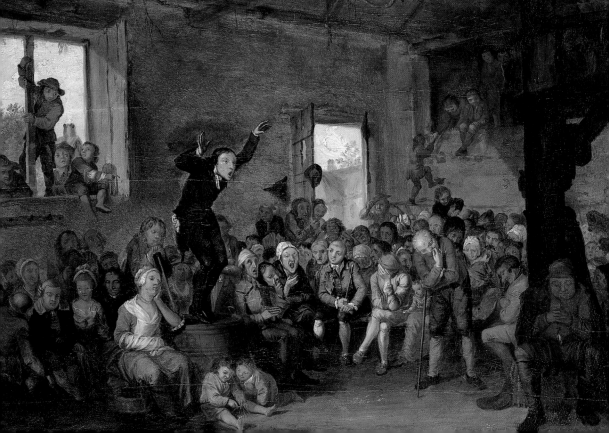

16. Portrait Busts

Figure sculpture in Ireland was traditionally associated either with religion or the dead, for example the Celtic idols, the scriptural portraits on high crosses and the tomb effigies. In the eighteenth century however, while religious figures and memorials to the dead were still being produced, sculptors were frequently commissioned to produce busts of living people. At the time, many great public buildings were being erected, and the aristocracy and the gentry were building fine mansions. In architecture and in art the neo-classical was in vogue and, recalling the ancient Roman fashion of statues in marble and bronze, those responsible for the new buildings adorned them with portrait busts of themselves or their associates, often represented in classical costume. Those portrayed were mostly members of the Protestant Ascendancy, and it is not until well into the nineteenth century that portrayals of Catholics appear in any numbers. Portrait busts of women are relatively rare for any period, and there are hardly any of children. The medium used was often white marble. To avoid lengthy sittings for the subject, the sculptor usually made a clay model before beginning to carve the marble. A clay model was also generally used for shaping the moulds for casting in bronze. In the nineteenth century the use of bronze became more widespread, especially for outdoor statues of public figures.

The Dublin Society was particularly enthusiastic about sculpture. It commissioned portraits, awarded premiums for outstanding work, and apprenticed pupils from the Society's Schools to John Van Nost, a gifted English sculptor of Dutch extraction who settled in Dublin about 1749. From the beginning the Dublin Society Schools were interested in sculpture and in 1811 the Society established a School of Modelling and Sculpture, the first two Masters of which were the father and son, Edward and John Smyth. One of the first of the many notable graduates of the School was John Henry Foley who became the leading sculptor of his day in England. He also executed a number of Irish commissions, including the O'Connell Monument in Dublin, and the statues of Burke and Goldsmith outside Trinity College. Like others, Foley abandoned the classical convention, dressed his figures in contemporary garb, and generally presented a lively and naturalistic interpretation.

51. Jonathan Swift (1667-1745), satirical writer and Dean of St Patrick's Cathedral, Dublin; marble by John Van Nost (d. 1780). (St Patrick's Hospital, Dublin)

52. Daniel O'Connell (1775-1847) by Peter Turnerelli (1774-1839). Born in Belfast, Turnerelli worked mostly in London. He executed this marble bust in 1828 on O'Connell's election as MP for Clare. (Castleknock College)

53. William Carleton (1794-1869), author of *Traits and Stories of the Irish Peasantry;* plaster by John Hogan (1800-1858). (NGI)

54. Sir William Rowan Hamilton (1805-65), mathematician and astronomer; a posthumous portrait in marble by John Henry Foley (1818-74), based on an earlier plaster by Thomas Kirk. (TCD)

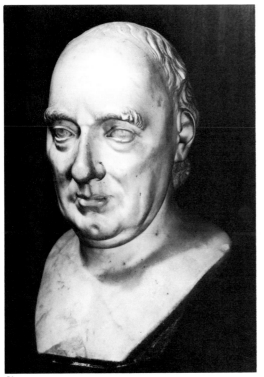

51

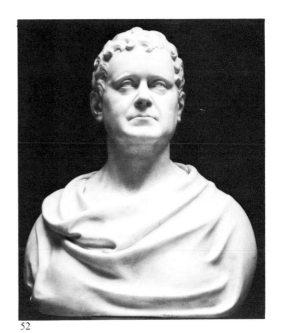

52

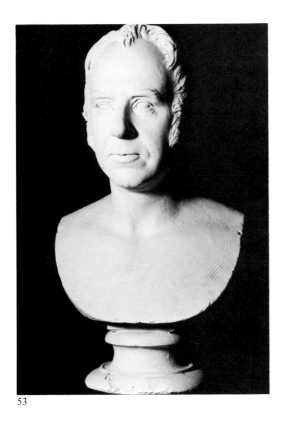

53

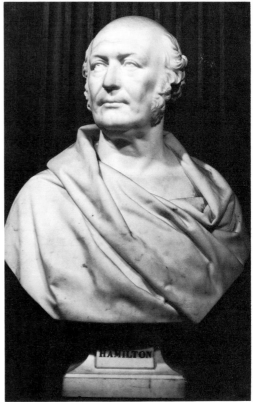

54

17. Anti-Irish Caricature

Throughout the ages the extent to which the structure of the human face reveals character or disposition has been a matter of debate. In ancient Greece, Hippocrates ('the Father of Medicine') and the philosopher Aristotle were both concerned with physiognomy, that is the relationship between facial appearance and personality. They held that the soul and body sympathise, and that facial features, complexion and texture of skin and hair, reveal those innate principles, physical and mental, which determine health, temperament, and ultimately behaviour. In the eighteenth and nineteenth centuries in Western Europe, the study of physiognomy developed into what might be called a discipline, and certain scientists considered the face almost as a contour map which could be read at a glance. Such theories have some basis in fact, but the study of physiognomy took a sinister turn when it was pursued in the context of man's descent from the apes. Scientists now looked for similarities between man and ape, and prognathism, that is a projecting mouth and jaw, was regarded as especially significant. The degree to which a person's jaw protruded beyond the vertical line of the face was thought to indicate the stage of progress in the evolution from primitive to civilised. This theory was extended to entire races, and in England the typical Anglo-Saxon was apprehended as near the civilised end of the scale, whereas the Irishman tended to be seen as close to the primitive.

Such prejudice was expressed graphically in caricatures and political cartoons in various English publications from the late eighteenth century onwards. According as the prejudice of certain classes in England was intensified by such episodes as the O'Connell agitation, the Fenian outrages and the Home Rule movement, the pictorial stereotype of the Irishman or 'Celt' became more brutish, dangerous and simian or ape-like. The most notorious portrayer of the simianised Irishman was *Punch* which first appeared in 1841, but there were also a number of other comic weeklies which descended to this level of political and racial comment. In the United States also, publications such as *Puck* and *Harper's Weekly* presented similar stereotypes, though there the prejudice was generally provoked by the machinations of the Irish in local politics.

55. The Irish nationalist Jeremiah O'Donovan Rossa as represented in the New York satirical magazine *Puck*, 10 August 1881, while he was in exile in the United States. (NLI)

56. The British Lion addressing John Mitchel at the time of his indictment for sedition, *Punch*, 8 April 1848. (NLI)

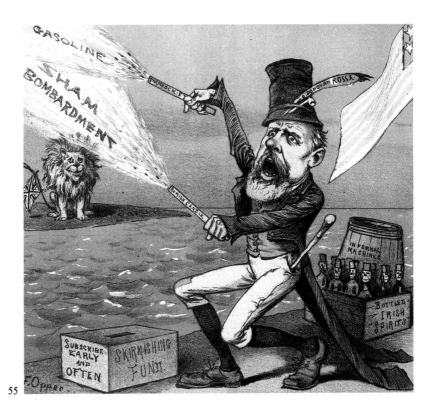

55

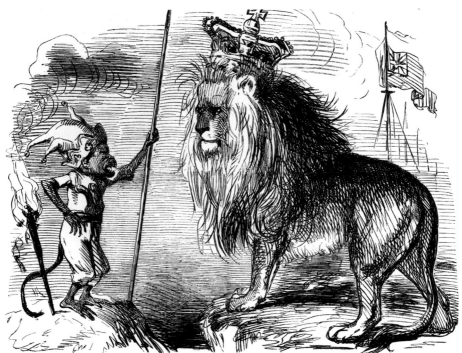

56

THE BRITISH LION AND THE IRISH MONKEY.

18. Irish Caricature

In Ireland the anti-Irish bias of the English cartoonists was naturally resented by the nationalist population. In response certain publishers tried to counter the stereotyped caricature of the Irishman, especially through the medium of comic weeklies, a number of which were published in Dublin in the period from 1870 to the first World War. Among these were *Pat, Ireland's Eye,* and *Zozimus* which aspired to being the Irish *Punch.* Most had brief runs but, in their time, they provided diversion and some political direction for their predominantly middle-class readership. Some of the cartoonists also did work for the commercial newspapers such as the *Weekly Freeman,* the *Weekly Irish Times* and the political organ *United Ireland,* all of which issued colour supplements featuring lively political cartoons. Together, the comic weeklies and the colour supplements created two new stereotypes, the female figure of Kathleen or Erin, and the sturdy tenant farmer Pat, two symbols of Irish beauty and integrity.

The pictorial stereotype of Pat became well established and to some extent influenced the portrayal of real personalities. For instance, Parnellite politicians were usually given standardised, regular features, and all tend to look alike, both in cartoons and formal illustrations. In their treatment of political opponents—landlords, Orangemen, officials and Government—the Irish cartoonists were as provocative as their English counterparts but within certain limits. Seemingly, the enemies of Ireland might be represented as monsters, knaves or fools but were less often made to look like apes. For tactical reasons, perhaps, the Irish cartoonists were reluctant to reciprocate in what they regarded as racialist and contravening the rules of fair comment.

The offensive caricature of the Irish was by no means universal in English magazines and newspapers. In contrast with the comic weeklies, which thrived on the outrageous, the serious press generally represented Irish people as not noticeably different from English people of corresponding class. Indeed, some publications tended to idealise the Irish, most notably the *Illustrated London News,* which invariably showed the Irishman as a well dressed and respectable figure, with regular features expressive of intelligence and manly fortitude — a figure almost identical to that presented by the Irish cartoonists.

57. 'Setting Down in Malice', 22 January 1881; *Pat,* published in Dublin 1879-83, described itself as 'An Irish Weekly Periodical; Artistic, Literary, Humorous, Satirical'. It strongly supported the Land League and Home Rule movements. The principal cartoonist, John Fergus O'Hea, showed that two could play at racialist caricature and sometimes simianised his English politicians. (NLI)

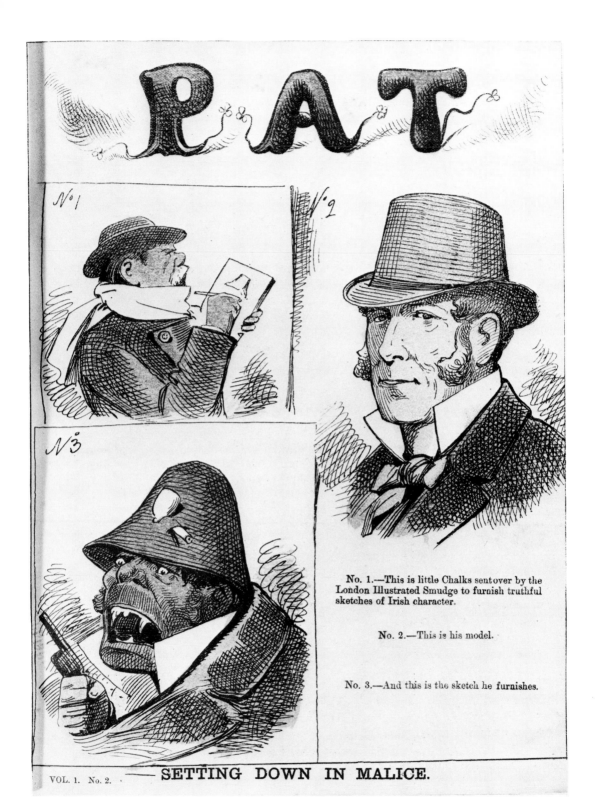

PAT

No. 1.—This is little Chalks sent over by the London Illustrated Smudge to furnish truthful sketches of Irish character.

No. 2.—This is his model.

No. 3.—And this is the sketch he furnishes.

SETTING DOWN IN MALICE.

19. Academic Portraiture

In any review of Irish portraiture, the contribution of the Royal Hibernian Academy of Arts must be recorded, in that it has provided a forum for a great many of the artists of the past two hundred years. To some extent modelled on the Royal Academy in England, the Royal Hibernian Academy was established by Royal Charter in 1823. At present its constitution provides for thirty elected members (RHA). There are also Associates (ARHA) and a number of Honorary Members, mostly people eminent in fields related to the fine arts. The Academy was designed to promote painting, sculpture and architecture, mainly by means of exhibition, and also by providing tuition for young artists. From the beginning the teaching function was largely duplicated by the Dublin Society Schools, and eventually the education of students was left to the National College of Art.

In practice the main activity of the Academy has been the organising of exhibitions. The first exhibition was held in 1826 in a gallery in Abbey Street donated by the great architect Francis Johnston. Exhibitions have been held most years since and, in all, about 60,000 works have been displayed. Only works which a panel of assessors consider to be of some merit are accepted and, undoubtedly, the exhibitions have helped to raise standards. Over the years the Academy exhibitions have represented most of the fashions and concerns of Irish art. In the field of portraiture they have put the heads of some thousands of Irish people on display and, year by year, these heads and faces have documented the contemporary styles in grooming and demeanour, demonstrating what may be termed the 'look' of the age.

The Royal Hibernian Academy has had a relatively stable history but its building in Abbey Street was destroyed during the Rising in 1916. Since then it has had problems in organising exhibitions as it did not have suitable premises of its own. However, in the nineteen seventies the late Matthew Gallagher erected a fine gallery for the Academy in Ely Place, where the annual exhibitions are now held.

58. Francis Johnston with his wife and nephews 1827, by Martin Cregan, President of the RHA 1832-57. The Armagh-born Johnston was architect of a number of important buildings, including the General Post Office, Dublin. (Ulster Museum)

59. Augusta Gregory (1852-1932), playwright; by John Butler Yeats RHA (1839-1922). (NGI)

60. Seán Keating, President of the RHA 1949-62; pastel by Thomas Ryan, PRHA 1982-. (Artist's collection)

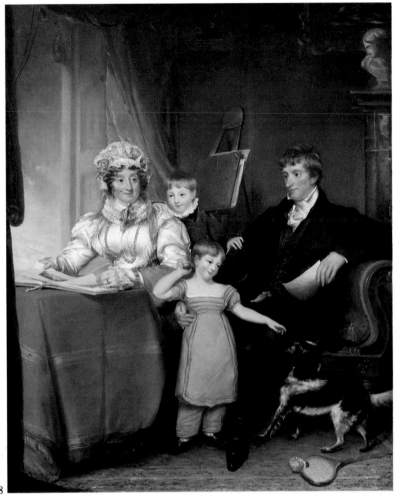

58

59

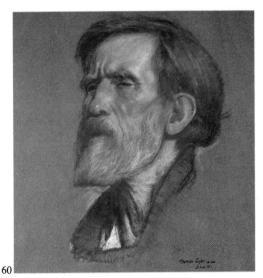

60

20. Portrait Medals

In Ireland the custom of issuing medals to commemorate events or to acknowledge merit became common in the eighteenth century. Most of the early specimens had illustrations of allegorical subjects, but towards the end of the century portraits were sometimes depicted. The portrait medals were usually designed as tributes to individuals who had made a notable contribution in a field such as politics, commerce, philanthropy or the arts. In many cases they were commissioned as limited editions by appreciative groups or individuals, but on occasion medallists produced batches of commemorative medals on their own initiative for sale on a commercial basis. Often the portrait was based on a bust or painting.

A medal may be considered as a form of sculpture in miniature. Large medals were usually cast. The medallist made a wax model which was then embedded in a mould. When the mould had hardened the wax was melted out and the molten metal was poured in. However, all the medals illustrated here were fashioned by striking, which is more practical for small medals, provided they are in a soft metal such as silver or bronze and that they are in relatively low relief. When striking, the medallist engraved two steel dies, a blank was placed between them, and the images on the dies were imprinted on the blank by means of intense pressure. Traditionally the pressure was exerted by a hammer-blow (hence the expression 'to strike a medal'), but by the time medals were first produced in Ireland some form of screw press was generally used.

Although there were usually only a few medallists active at any one time there was not enough work to keep them fully employed. Their main business tended to be the sinking of dies for use in the manufacture of seals, coins and tokens, and the ornate metal buttons then in fashion. The best known of the Irish medallists were William Mossop, his son William Stephen Mossop, William Woodhouse and his son John. Altogether their careers as medallists spanned a period of over a hundred years, from about 1782 to 1886. Though they were not particularly successful in commercial terms, their medals were notable for their artistic designs and a high standard of craftsmanship.

Note: All items are NMI.

61. Dr Henry Quin (1718-91); a respected Dublin physician, Quin commissioned the medal; silver 1782 by William Mossop (1751-1805).

62. Sir Benjamin Lee Guinness (1798-1868), Dublin brewer commemorated for restoring St Patrick's Cathedral; bronze by Isaac Parkes (c. 1791-1870).

63. James Caulfield, Earl of Charlemont (1728-99); bronze by William Stephen Mossop (1788-1827) to commemorate 'the Volunteer Earl'.

64 Fr Theobald Mathew (1790-1856); bronze by William Woodhouse (1805-78) to commemorate the crusade for temperance.

65. William Dargan (1799-1867), the great railway contractor who financed the Industrial Exhibition of 1853; white metal by William Woodhouse.

66. Oliver Goldsmith (1728-74), poet, playwright and novelist; bronze by William Woodhouse.

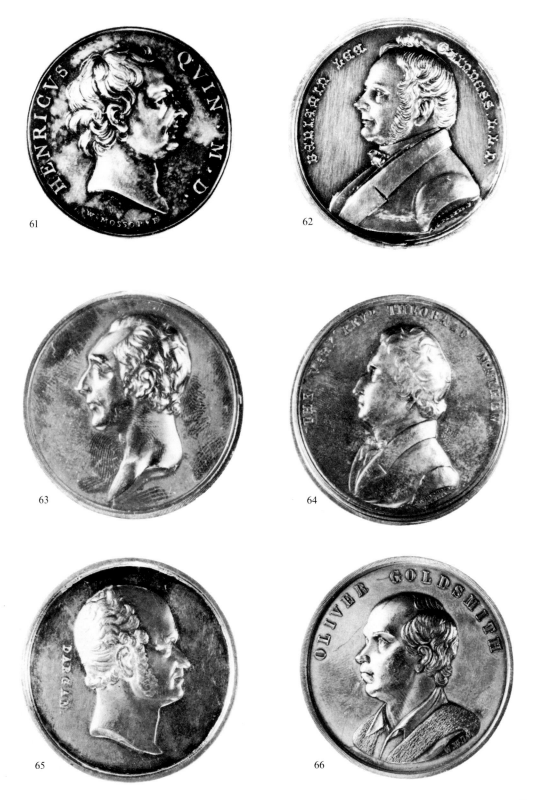

61

62

63

64

65

66

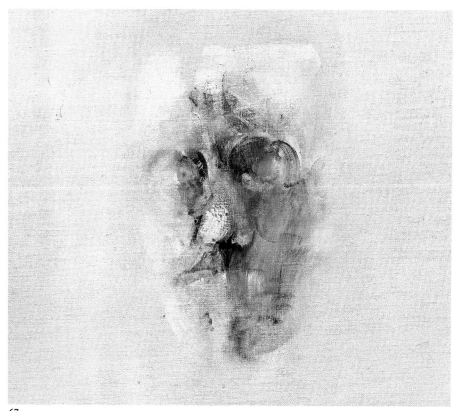

67

68

21. Modern Painting

In the decades following Independence many artists were concerned with concepts of national identity, and in portraiture they were preoccupied with typical rural subjects and personalities associated with the birth of the new State. At the same time, innovations in matters of technique, style and subject matter were being introduced by a generation of artists who had trained or worked on the Continent. Among these were figures such as Louis le Brocquy who experimented with representing emotional and psychological states, and Mainie Jellett and Evie Hone who promoted abstract and Cubist forms, some expressed in the medium of stained glass. The Royal Hibernian Academy was naturally cautious about exhibiting novel styles which in retrospect might prove to have no great artistic validity. In reaction, in 1943 a number of artists who worked in 'avant garde' idioms established the Irish Exhibition of Living Art which, over the years, has provided an outlet for those of an experimental persuasion. The current situation is that, in general, artists who adhere to the more traditional forms exhibit at the RHA while the 'moderns', especially younger artists, are catered for by groups or institutions such as the Exhibition of Living Art, the Independent Artists, An tOireachtas, the Graphic Studio, and various Arts Centres around the country.

Modern art of its nature is concerned with experiment, and perhaps the most notable feature of the movement in Ireland since the fifties has been its diversity, in styles, in media and in techniques. There has been a relatively small proportion of portraits partly because patrons tend to give their commissions to those whom they perceive as the safer traditional artists. In portraiture the moderns generally avoid the photographic style and, somewhat in the manner of the caricaturist, often express the nature of the subject by concentrating on selected aspects. The technique frequently relies on strong colours, clear lines and and well defined shapes, which make the picture ideal for reproduction by one of the modern printing processes.

67. Image of James Joyce, 1978; a posthumous portrait of the writer (1882-1941) by Louis le Brocquy (b.1916); oil on canvas, detail. (Artist's collection)

68. Seán O'Casey (1880-1964), author of *The Plough and the Stars,* by Robert Ballagh (b. 1943); acrylic on canvas. (London Tara Hotel)

22. Twentieth Century Sculpture

In the early twentieth century many of the younger Irish sculptors were influenced by the international Art Nouveau movement. Generally, their figures are pleasantly realistic and have a sense of movement and vigour. In the early decades the most important sculpture was in the medium of public monuments. One of the best known examples is the lively *Parnell Monument* in O'Connell Street, Dublin, by the Irish-born Augustus St Gaudens who spent most of his life in the United States. Another notable artist who spent much of his life in the United States was Jerome Connor from Annascaul in Kerry. He was responsible for the *Lusitania Memorial* in Cobh, and a cast of his Robert Emmet is now in St Stephen's Green in Dublin, facing the Royal College of Surgeons. A number of recent monuments are by Edward Delaney, among which in Dublin are Thomas Davis in College Green and Wolfe Tone in St Stephen's Green.

Commissions for portrait busts were relatively common in the first half of the century, with bronze generally replacing marble. Oliver Sheppard produced a number of portraits and, as Head of Sculpture at Dublin's Metropolitan School of Art, he trained a generation of students. Prominent among these was Albert Power who executed portrait busts of many of the national figures of his time. More modern trends are represented in the work of F.E. McWilliam who has experimented with abstract and Surrealist forms. However, while he trained at the Belfast School of Art, McWilliam has worked mainly in England and is hardly typical of Irish figure sculptors. Nowadays most commissions come from public bodies, or commercial or religious institutions, which generally prefer traditional forms. For instance, thirteen bronze heads of twentieth century writers recently acquired by the Library of the Royal Dublin Society are in an attractive naturalistic style. They are by Marjorie FitzGibbon and were cast in the Dublin Art Foundry.

The age-old tradition of carving in stone has been continued by artists such as Séamus Murphy (author of *Stone Mad*), and Domhnall Ó Murchadha, a former Head of Sculpture at the National College of Art. An increasing number of sculptors are now exploiting the traditional materials of stone and wood to produce simple and evocative figures and faces.

69. Detail of *Princess Macha;* bronze by F.E. McWilliam (b. 1909). (Altnagelvin Hospital, Derry City)

70. W.B. Yeats (1865-1939), poet; bronze by Albert Power (1883-1945). (NGI)

71. George Russell (1867-1935), the writer and artist AE; sandstone by Oliver Sheppard (1865-1941). (NGI)

72. Mary Lavin (b. 1912), writer; bronze by Marjorie FitzGibbon. (RDS)

73. Séamus Murphy (1907-75) in his workshop in Cork. Photograph by Tomás Ó Muircheartaigh, *Feasta*, Iúil 1960.

69

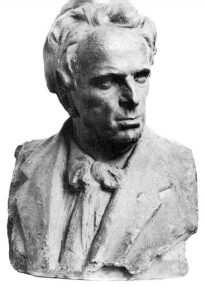

70

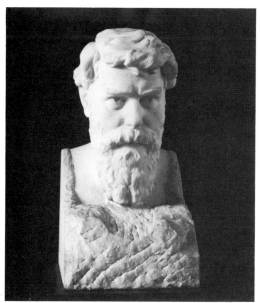

71

72

73

23. Alternative Perspectives

The personality of a well known public figure is often best expressed by a caricature, cartoon or other oblique view provided by a humorous, mischievous or quirky artist. The National Library has numerous specimens of this form of art, most of which have appeared over the years in newspapers and magazines, although some are unpublished.

74 GRACE PLUNKETT/23

75 doll

74. Barry Fitzgerald (i.e. W.J. Shields), Eileen Crowe, Arthur Shields and Sara Allgood in *The Glorious Uncertainty* by Brinsley McNamara; by Grace Plunkett (née Gifford), 1923. (NLI)

75. Jack Lynch (b. 1917), former Taoiseach, by 'Doll' (Flann Ó Riain), *Irish Independent.*

76. Richard Pigott (c. 1828-1889), journalist and forger, by 'Spy' (Leslie Ward), *Vanity Fair,* 9 March, 1889.

77. George Sigerson (1836-1925), physician and man of letters, by Tom Lalor. (NLI)

78. George Bernard Shaw (1856-1950), playwright, by 'Ben Bay' (Benjamin T. Bailey). (NLI)

79. Austin Clarke (1896-1974), poet, by Robert Pyke. (NGI)

80. Douglas Hyde (1860-1949), Gaelic scholar and first President of Ireland, by Frank Leah. (NLI)

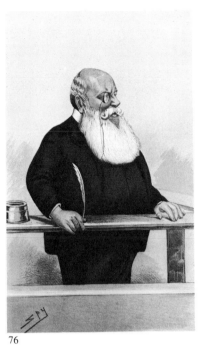

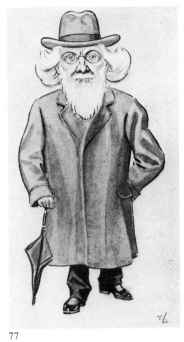

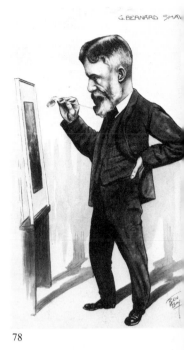

76

77

78

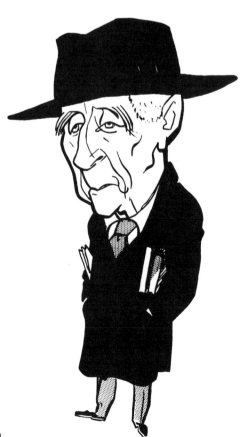

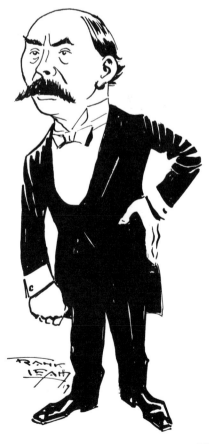

79

80

24. Professional Photographers

Portraiture was generally confined to members of the upper classes until the development of photography enabled people of every station to have their pictures 'taken' quickly and relatively cheaply. In 1839 two different photographic processes were made public, one by a Frenchman, Daguerre, and the other by an Englishman, William Henry Fox Talbot. With the daguerrotype the image was imprinted on a copper plate. It was a positive process so that each plate constituted a once-off photograph and copies could not be taken from the plate. Fox Talbot's process known as calotype produced a negative image on paper and it had the advantage that any number of positive copies could be made from the negative. However, the daguerrotype gave better definition and was favoured by the early commercial photographers. In the eighteen forties a number of daguerrotype studios specialising in portraiture were established in Dublin and other cities and towns.

The calotype process was used mainly by amateur photographers but in 1851 the wet-plate process was developed and rendered both the calotype and the daguerrotype obsolete. It used a glass-plate negative instead of a paper negative, the exposure period was reduced to a matter of seconds, and the quality of definition was greatly improved. But in 1878 the wet-plate was itself superseded by the dry-plate process which largely eliminated the use of messy chemicals and simplified the whole operation.

The main business of commercial photographers was portraiture. To reduce costs a number of photographs were often taken on sections of the one glass negative and the resulting small prints, about the size of a visiting card and known as *cartes de visite,* became extremely popular. As well as portraiture some photographic firms engaged in the mass production of views of beauty spots and other subjects suitable for the tourist market which they sold as prints, or in albums, or as postcards. Among the surviving collections of glass plate negatives generated by commercial firms are the Lawrence Collection in the National Library (40,000 plates, c. 1870-1910); the Welch Collection in the Ulster Museum (5,300 plates, c. 1875-1900); and the Cooper Collection in the Public Record Office of Northern Ireland (200,000 plates, c. 1913-1960).

81. Mary Sullivan from the Gap of Dunloe, Killarney, Co. Kerry, period 1860-80. (NLI, Stereo Pairs Collection)

82. Maud Gonne (1866-1953); born in England but possibly of remote Irish ancestry she was regarded as the quintessential Irish beauty. The photograph is a near life-size contact print taken with a camera the size of a small furniture van by Alfred Werner in 1893. (Photographic Society of Ireland)

83. Eamon de Valera (1882-1975); probably taken in a London studio in January 1922 for use on a passport when he travelled to the Irish Race Congress in Paris disguised as a priest. (NLI)

84. John and Sarah Graham, orphans; commissioned from a Dublin studio by the Protestant Orphan Society, c. 1880. (Public Record Office of Ireland)

85. Teelin fishermen, Co. Donegal, period 1880-1910. (NLI, Lawrence Collection)

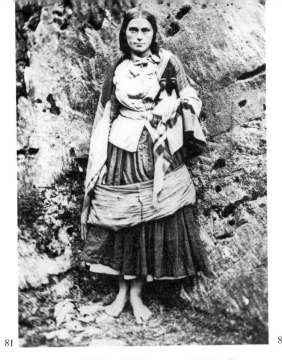

81

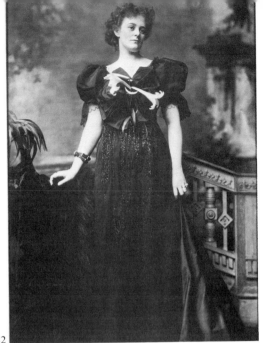

82

83

84

85

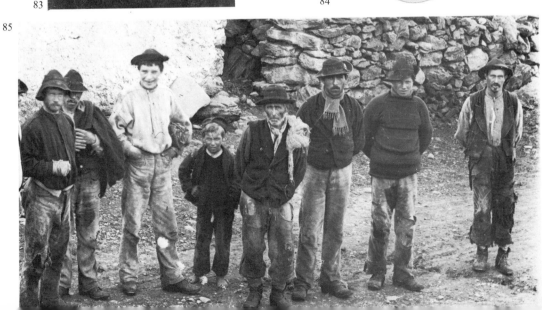

25. Amateur Photography

Apart from the professional photographers an ever increasing number of amateurs were active from the eighteen forties onwards. Some were members of the aristocracy and the landed gentry, and among the great houses where important collections of photographs were generated were Lismore Castle, Birr Castle, and Clonbrock, Co. Galway. Those at Birr Castle were taken mainly by Mary, Countess of Rosse (1813-1885). Those at Clonbrock were mainly by Luke Gerald Dillon, 4th Baron Clonbrock (1834-1917), and his wife Augusta (née Crofton, of Mote Park, Co. Roscommon). The photographs record the faces of various people associated with the houses, including family, servants and visitors.

86. The Tracey family, Ahascragh, Co. Galway, 1900. (NLI, Clonbrock Collection)

87. Lord Dunlo with a stereo camera (for taking 'twin' photographs which gave a three-dimensional effect when viewed in a stereoscope), 1864. (NLI, Clonbrock Collection)

88. Johnny Mason, the third generation of his family to act as 'park keeper' at Clonbrock, c. 1880. (NLI, Clonbrock Collection)

89. Detail showing Tommy Birmingham and a man named Coghlan beside the 6 foot reflector for the great telescope after repolishing in the Birr Castle workshops; by Laurence Parsons, 4th Earl of Rosse, 1884. (Birr Scientific Heritage Foundation)

90. Thomas Romney Robinson (1792-1882), astronomer and mathematical physicist, by Mary Rosse, c. 1855-56. (Birr Scientific Heritage Foundation)

91. 'Four Boys with a Rabbit': William, John, Laurence and Randal Parsons; by Mary Rosse, 1854. (Birr Scientific Heritage Foundation)

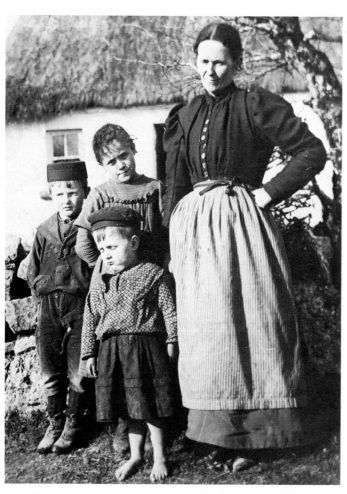

86

87

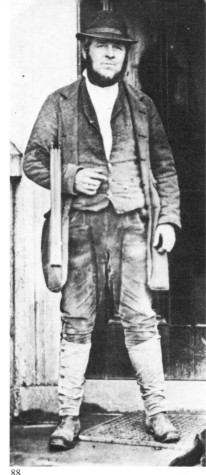

88

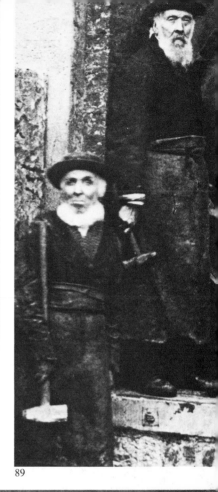

89

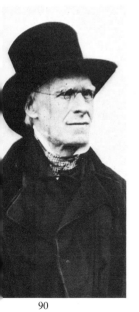

90

91

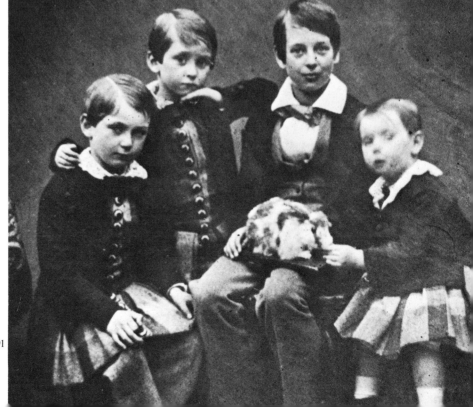

26. Prison Photographs

Among the Fenian Papers in the State Paper Office in Dublin Castle are photographs of several hundred persons detained as suspects in the period 1865-67. This seems to have been the first occasion that the authorities in Ireland used photography on a large scale for purposes of identification. The State Paper Office also has a much larger number of photographs of ordinary convicts among the Penal Records of the General Prisons Board. In most cases the photograph was taken when the convict was discharged, but some files include a sequence of photographs taken at intervals of three years. They provide an important record of the appearance of convicts in Irish prisons in the period 1881-1927.

Note: All items are State Paper Office.

92. James Melia, Mullingar. Age 29, 5′ 8″, cattle dealer, fresh complexion, brown hair, grey eyes. (Fenian Papers)

93. Patrick O'Brien, Castleisland. Age 27, 5′ 8″, farmer, fresh complexion, dark brown hair, brown eyes. (FP)

94. Michael Crinnion, Drumlish, Co. Longford. Age 40, 5′ 5″, land and sheriff's bailiff, fresh complexion, grey hair, hazel eyes. (FP)

95. J. Nolan, no description in file. (FP)

96. Martin McDonagh, Roscommon. Age 77 (on conviction), grey hair, grey eyes; larceny, 5 years from 1897. (General Prisons Board)

97. Lizzie Russell, Dublin. Age 44, brown hair, hazel eyes; malicious damage, 3 years from 1907. (GPB)

98. James Dickson, Co. Down. Age 57, no description; assault, 5 years from 1906. (GPB)

92

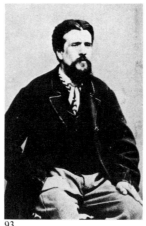

93

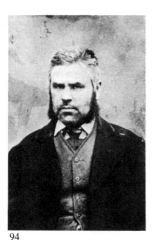

94

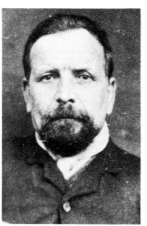

95

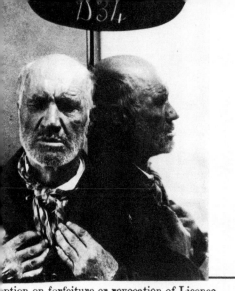

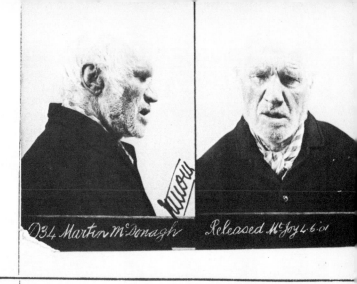

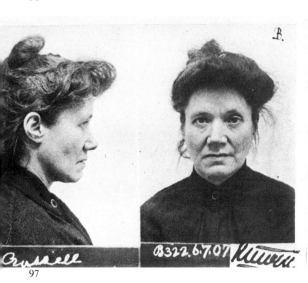

D34 Martin McDonagh Released McJoy 4.6.01

ption on forfeiture or revocation of Licence On final discharge
96

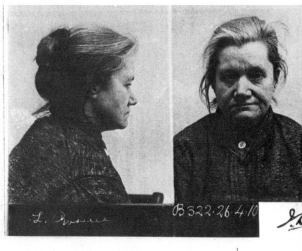

Crassell B322.6.7.07

L. Russell B322.26.4.10
97

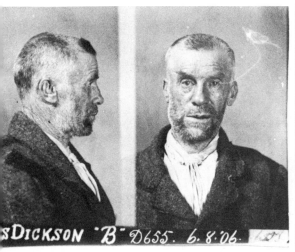

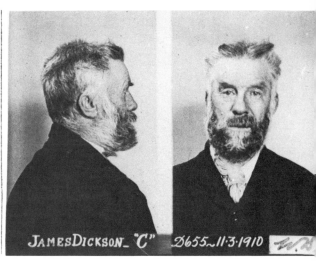

SDICKSON "B" D655. 6.8.'06. JAMES DICKSON "C" D655. 11.3.1910
98

27. Anthropological Photographs

Since the eighteen nineties anthropologists have carried out a number of studies concerned with identifying the various ethnic strains in the population in Ireland. The most ambitious was a survey conducted in the nineteen thirties by a team from Harvard University in the United States. This involved a sample of 10,000 adult males, selected at 426 locations throughout the thirty-two countries, and 1,800 females along the west coast. Each was examined and a record was made in respect of weight, height, length and breadth of head and of individual facial features. The colour of hair, skin and eyes was also noted. On the basis of this data each person was classified. Those surveyed were identified as belonging to the groups, 'Keltic', 'Dinaric' (Balkan), 'Nordic', 'East Baltic', 'Mediterranean', or to the mixed groups, 'Nordic Mediterranean' or 'Nordic Alpine'. The survey classified the population at large as mainly consisting of 28% Nordic Mediterranean, 25% Keltic, 19% Dinaric, 18% Nordic Alpine and 7% Nordic. Furthermore, it claimed to have established the relative proportions of the various types county by county; for instance it claimed a high percentage of Celts in Wicklow and in the Aran Islands but a low percentage in Mayo and Cork; Nordic types were above average in Wexford-Waterford, Longford-Westmeath and West Galway; a high incidence of the relatively small number of East Baltics occurred in Cork-Kerry and in Derry-Tyrone.

There is some validity in the conclusions of the Harvard study as it is sometimes possible, even in a country where 'races' have intermingled as much as in Ireland, to generalise regarding the ethnic types which predominate in particular areas. However, the findings cannot be regarded as at all reliable as they are based on a relatively small selection of traits in the individual subjects, and a number of important genetic indicators, for instance blood groups, were not taken into account. The survey was eventually published and an interesting feature of the 500 page report is a collection of photographs of 188 male participants from various parts of the country, a selection of which are reproduced here.

99. No. 505: Aran Islands. Age 40, 6′ 0″, brown hair, grey-blue eyes; 'Dinaric'.

100. No. 1151: Leitrim. Age 54, 5′ 6″, dark brown hair, brown eyes; 'Mediterranean'.

101. No. 4431: Leitrim. Age 81, 5′ 3″, red-brown hair, blue eyes; 'Nordic Alpine'.

102. No. 5402: Kerry. Age 42, 5′ 9″, brown hair, blue eyes; 'Keltic'.

103. No. 5538: Cork. Age 71, 5′ 8″, red hair, blue eyes; 'East Baltic'.

104. No. 6417: Tipperary. Age 18, 5′ 7″, golden hair, grey-blue eyes; 'Nordic'.

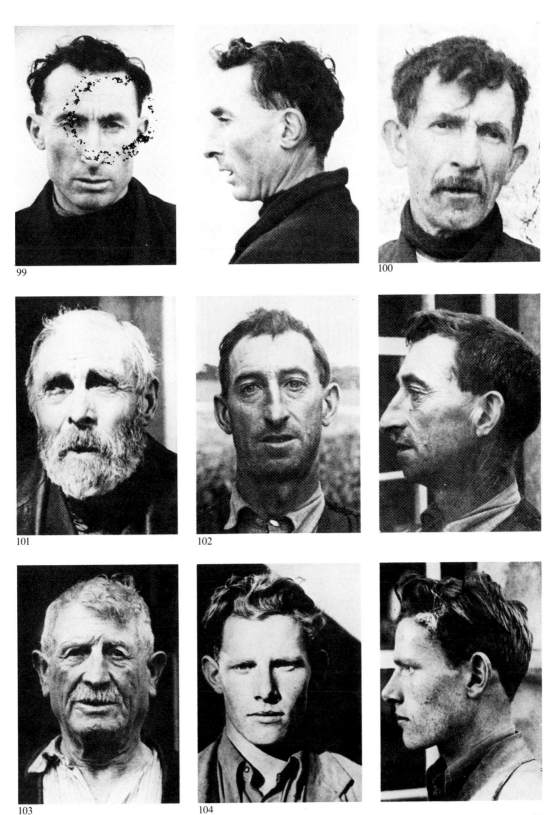

99

100

101

102

103

104

Sources for Quotations in the Text

Arthur Young, *A Tour in Ireland,* ed. A.W. Hutton (Shannon 1970), vol. II, p. 144.

Department of Irish Folklore, University College, Dublin: the collections include many references to aspects of physical appearance which can be located through the indexes.

Edaín, Deirdre, Froech: K.H. Jackson, *A Celtic Miscellany* (London, Routledge and Kegan Paul, 1951), pp. 196, 50, 185.

Burke on beauty: P. Magnus, *Edmund Burke* (London 1939), p. 331.

Táin Bó Cuailnge from the Book of Leinster, ed. Cecile O'Rahilly (Dublin 1967) — descriptions, pp. 254-60.

Skarp Hedin: *Njal's Saga,* translated by M. Magnusson and H. Pálsson (London, Penguin, 1983), p. 83.

Giraldus Cambrensis, *The History and Topography of Ireland,* translated by J.J. O'Meara (Mountrath 1982) — descriptions of the Irish, pp. 100-101.

Giraldus Cambrensis *Expugnatio Hibernica: The Conquest of Ireland,* ed. by A.B. Scott and F.X. Martin (Dublin 1978) — descriptions: MacMurchada, p. 41; Maurice FitzGerald, p. 119; de Lacy, p. 193.

Art MacMurrough Kavanagh: J. Webb, 'Translation of a French Metrical History', in *Archaeologia* XX (1824), p. 40.

Statute 1297: E. Curtis and R.B. McDowell, *Irish Historical Documents 1172-1922* (London 1968), p. 37.

Statute 1537: *The Statutes at Large 1310-1761* (Dublin 1765), vol. I, p. 131.

Edmund Spenser, *A View of the Present State of Ireland,* ed. W.L. Renwick (Oxford 1970), p. 53.

Luke Gernon 'A Discourse of Ireland', in C.L. Falkiner, *Illustrations of Irish History and Topography* (London 1904), p. 357.

Bibliography

B. Arnold, *A Concise History of Irish Art* (London 1977).

J. Brophy, *The Face in Western Art* (London 1963).

E. Chandler, *Photography in Dublin during the Victorian Era* (Dublin 1983).

Concise Catalogue of the Drawings, Paintings and Sculptures in the Ulster Museum (Belfast 1986).

A. Crookshank, *Irish Sculpture from 1600* (Dublin 1984).

A. Crookshank and the Knight of Glin, *Irish Portraits 1660-1860* (London 1969).

A. Crookshank and the Knight of Glin, *The Painters of Ireland 1660-1920* (London 1978).

L. Curtis, *Nothing but the Same Old Story: The Roots of Anti-Irish Racism* (London 1985).

L.P. Curtis, *Anglo-Saxons and Celts: A Study of Anti-Irish Prejudice in Victorian England* (Connecticut, 1968).

L.P. Curtis, *Apes and Angels: The Irishman in Victorian Caricature* (Newton Abbot, 1971).

B. de Breffny, ed., *The Irish World* (London 1977).

B. de Breffny, ed., *Ireland: A Cultural Encyclopaedia* (London 1983).

M. and L. de Paor, *Early Christian Ireland* (London 1978).

R.M. Elmes, *Catalogue of Engraved Irish Portraits ...* (Dublin 1938).

G. Eogan and H. Richardson, 'Two Maceheads from Knowth', in *Journal of the Royal Society of Antiquaries of Ireland* 112 (1982), pp. 123-138.

W. Frazer, *The Medallists of Ireland and their Work.* Reprints from the *JRSAI* (Dublin 1886-93).

J. Graham-Campbell and D. Kidd, *The Vikings* (London 1980).

P. Harbison, H. Potterton and J. Sheehy, *Irish Art and Architecture* (London 1978).

F. Henry, *Irish Art,* 3 vols. (London 1965-70).

F. Henry, *The Book of Kells* (London 1974).

John Hewitt and Theo Snoddy, *Art in Ulster: 1* (Belfast 1977).

H. Hickey, *Images of Stone* (Belfast 1986).

F.E. Hogan, *The Irish People: Their Height, Form and Strength* (Dublin 1899).

E.A. Hooton and C.W. Dupertuis, *The Physical Anthropology of Ireland* (Papers of the Peabody Museum of Archaeology and Ethnology, Harvard University, XXX, nos. 1-2, 1955).

J. Hunt (with contributions by P. Harbison), *Irish Medieval Figure Sculpture 1200-1600,* 2 vols. (Dublin and London 1974).

R. Knowles, ed., *Contemporary Irish Art* (Dublin 1982).

A.T. Lucas, 'Washing and Bathing in Ancient Ireland', in *JRSAI* 95 (1965), pp. 65-114.

A.T. Lucas, *Treasures of Ireland: Irish Pagan and Early Christian Art* (Dublin 1973).

P. Mac Cana, *Celtic Mythology* (London 1983).

H.F. McClintock, *Old Irish and Highland Dress* (Dundalk 1950).

S. Murphy, *Stone Mad* (London 1966).

National Gallery of Ireland, *Catalogue of the Sculptures* (Dublin 1975).

National Gallery of Ireland, *Illustrated Summary Catalogue of Paintings* (Dublin 1981).

National Gallery of Ireland, *Illustrated Summary Catalogue of Drawings, Watercolours and Miniatures,* compiled by Adrian Le Harivel (Dublin 1983).

T.G.E. Powell, *The Celts* (London 1980).

E. Rynne, 'Celtic Stone Idols in Ireland', in *The Iron Age in the Irish Sea Province,* ed. C. Thomas (London 1972), pp. 79-98.

A. Stewart, *Fifty Irish Portraits* (Dublin 1984).

A. Stewart, *Royal Hibernian Academy of Arts: Index of Exhibitors and Their Works 1826-1979,* vol. I A-G (Dublin 1985).

W.G. Strickland, *Dictionary of Irish Artists,* 2 vols. (Shannon 1969).

A. Tomlinson, *The Medieval Face* (London 1974).

Treasures of Early Irish Art 1500 BC to 1500 AD ... Exhibited at the Metropolitan Museum of Art (New York 1977).

Treasures of Ireland: Irish Art 3000 BC — 1500 AD, ed. Michael Ryan (Dublin 1983).

Historical Documents

THE NATIONAL LIBRARY OF IRELAND has extensive collections of historical documents, for instance proclamations, nineteenth century newspapers, manuscript letters, deeds, maps and old photographs. Normally these are used by historians researching various aspects of the past but the National Library is now publishing folders of reproductions for the benefit of schools and also the general adult public.

Each folder relates to a particular aspect of Irish history or culture and consists of twenty to thirty documents. Those currently available are:—

1. **THE LAND WAR 1879-1903:** Documents include an eviction notice, police reports, extracts from newspapers and Parliamentary Papers, with explanatory text.
2. **THE LANDED GENTRY:** Items selected from collections of estate and family papers in the National Library. They illustrate the history and the way of life of the landed gentry in Ireland in the eighteenth and nineteenth centuries.
3. **DANIEL O'CONNELL:** Documents illustrating the career of O'Connell (1775-1847), with chronology and commentaries.
4. **PÁDRAIC MAC PIARAIS: Pearse from Documents:** Documents illustrating the career of Pearse (1879-1916) as journalist, teacher, political theorist and revolutionary. *Text in Irish & English.*
5. **IRELAND 1860-80 FROM STEREO PHOTOGRAPHS:** Twenty-five A4 photographs, based on a collection of stereographs from the period 1860-1880. They illustrate housing and architecture, transport, costume, social classes and recreation. With commentaries and associated documentation.
6. **ATHBHEOCHAN NA GAEILGE (The Irish Revival):** Items illustrating the Irish language and cultural revival from the beginning of the nineteenth century. Includes the minutes of the first meeting of the Gaelic League (1893); photograph of the Representative Congress, 1900; pages from **An Claidheamh Soluis** and **Feasta,** and documents relating to **Comhdháil Náisiúnta na Gaeilge.** *Text in Irish.*
7. **GRATTAN'S PARLIAMENT:** Documents relating to aspects of the Irish Parliament, 1782-1800, including the Irish Volunteers, the Dungannon Convention, Grattan's Declaration of Irish Rights, legislation of the Parliament, the Act of Union.
8. **JAMES JOYCE:** Documents illustrating the life and writings of James Joyce (1882-1941).
9. **THE PAST FROM THE PRESS:** Extracts from over thirty newspapers from the period 1660-1978; includes items relating to the 1798 Rebellion, the Fenians, the Civil War, the Mother and Child Scheme, Irish victories in the Olympics.
10. **IRELAND FROM MAPS:** Consists of a booklet (20 pages) and 16 maps (sizes A4, A3, A2) including 6 in colour. It illustrates the stages in the development of the map of Ireland and indicates the importance of maps as sources for Irish history. Includes maps by Ptolemy, Mercator, Speed, Petty, the Ordnance Survey and various estate surveyors.
11. **THE G.A.A.:** Documents relating to the founding of the Gaelic Athletic Association in 1884 and recording the principal events in its history.